PORTRAITS

Belvedere College, Dublin 1832—1982

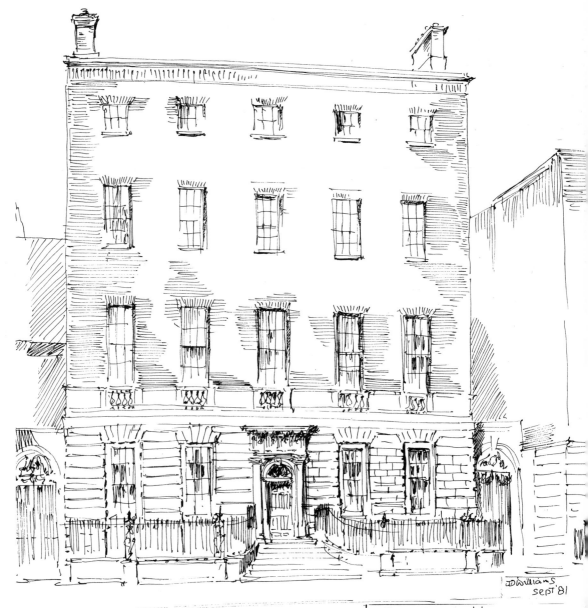

Belvedeve House
Front Facade 1786

PORTRAITS

BELVEDERE COLLEGE
DUBLIN
1832-1982

Edited by John Bowman
and Ronan O'Donoghue

Original photographs by Derek Speirs

GILL AND MACMILLAN

First published 1982 by
Gill and Macmillan Ltd
Goldenbridge
Dublin 8
with associated companies in
London, New York, Delhi, Hong Kong,
Johannesburg, Lagos, Melbourne,
Singapore, Tokyo

7171 1235 7

Origination by Healyset Ltd, Dublin
Printed by Criterion Press Ltd, Dublin
Bound by John F. Newman and Son Ltd, Dublin.

Contents

EDITORS

John Bowman, B.A.(Mod.), Ph.D.(TCD). Born Dublin, 1942; educated Belvedere College and Trinity College Dublin. Broadcaster, journalist, author of *De Valera and the Ulster Question: 1917–1973*, forthcoming from Oxford University Press.

Ronan O'Donoghue, B.A.(NUI). Born Dublin, 1957; educated Belvedere College and University College Dublin. Joined RTE as a current affairs producer in 1980; formerly attached to the Department of the Public Service.

ILLUSTRATORS

Derek Spiers, B.A.(CNAA), M.A.(RCA), born Dublin, 1952. Began professional career in London, returning to Ireland in 1978 to establish the *Report* photography agency, specialising in politics and current affairs. His photographs were included in *The Magill Book of Irish Politics*, 1981.

Jeremy Williams, B.Arch.(NUI). Born Dublin, 1943; educated Glenstal Abbey, UCD. Architect with particular interest in eighteenth-century Dublin and in urban renewal.

CONTRIBUTORS

Paul Andrews, S.J., M.A., H.Dip.Ed.(NUI), Lic.Phil.(Munich), S.T.L. (Gregorian University), M.Psych.Sc.(NUI), Ph.D.(Birmingham). Born Omagh, Co. Tyrone, 1927; educated by the Cross and Passion Sisters, Irish Christian Brothers, Benedictines, Jesuits, Diocesan priests and Holy Ghost Fathers. Psychologist and educationalist involved in policy-making, teaching and administration. Director, St Declan's School, Dublin; Rector, Belvedere College, 1976—

Owen Dudley Edwards, B.A.(NUI). Born Dublin, 1938; educated Belvedere College, UCD, and Johns Hopkins University, Baltimore. Lecturer in history, University of Edinburgh, 1968— . Along with various publications on Irish history, has written on American politics, Sherlock Holmes and P. G. Wodehouse.

William G. Fallon, B.A., S.C. Born Dublin, 1881; educated Belvedere College and UCD. Secretary to the Irish Parliamentary Party and a candidate in the Westminster election, January 1910. Withdrew from politics with the collapse of the Irish Party in 1918. Called to the Bar, 1920, and to the Inner Bar, 1964. A schoolmate of James Joyce at Belvedere, he subsequently maintained his friendship with Joyce, meeting him regularly in Paris in the 1920s after the Ireland-France rugby international. Founder member and past president, Belvedere College Union.

William Fogarty. Born 1880. Taught in France and Canada before becoming French master at Belvedere, a post he held for forty years until his death in June 1950.

F. X. Martin O.S.A., M.A.(NUI), L.Ph.(Rome), B.D.(Rome), Ph.D. (Cambridge). Born Ballylongford, Co. Kerry, 1922; educated Ring College, Belvedere College, UCD, Gregorian University Rome, Cambridge University. Professor of Medieval History, UCD, 1962— ; co-editor, *A New History of Ireland*, Oxford 1974— . Principal figure in the Wood Quay *cause célèbre* for the preservation of Viking and medieval remains in Dublin. Prolific writer on twentieth-century Irish history.

Conor O'Brien, B.A.(NUI), B.L.(King's Inns). Born Dublin, 1928; educated Belvedere College, UCD, King's Inns. Barrister, journalist, newspaper executive, Independent Newspapers. Former editor, *Evening Press, Sunday Independent.*

T. C. J. O'Connell, M.D., M.Ch., F.R.C.S.I., B.Sc. Born Streamstown, Co. Westmeath, 1906; educated Belvedere College, UCD and in Britain, Germany and Austria. Senior Consultant Surgeon, St Vincent's Hospital, Dublin. Founder member and ex-President, Old Belvedere RFC.

Mervyn Wall, born Dublin, 1908; educated Belvedere College and in Germany. Worked in civil service, Radio Éireann and the Arts Council. Writer of novels, short stories, plays, criticism, and a volume of local history, *Forty foot gentlemen only*. His novels are considered to be his best work, most notably *The Unfortunate Fursey*. Excerpts from a novel he is currently writing, *Hermitage* — including accounts of his years in Belvedere — have been published in the *Journal of Irish Literature*, Newark, Delaware.

Introduction-
'...heresy in his essay'

Books published to mark an important anniversary in the life of an institution rarely make interesting reading to outsiders. This is particularly true when the initial idea — as is the case with this book — originates from a source close to the institution in question. Should this book prove an exception to the rule it is probably due to one factor: that the editors, having been entrusted with the job, were thereafter left severely alone by the organising committee, whose members open these pages, as any good newspaper proprietor does — on the day of publication. Should any reader respond as did Mr Tate to one of Stephen's essays in Joyce's *Portrait*, with the charge that 'This fellow has heresy in his essay', responsibility must rest solely with the editors.

Schooling is an intimate experience: whether the individual's response to his *alma mater* is one of indebtedness or alienation, whether he regards the days and years spent there as among the happiest of his life or otherwise, reminiscences are of value and interest only to the extent that they are honestly recorded. Moreover, in editing a book of this kind, it is necessary to avoid what Willie Fallon, in another context, listed as a number of dangerous 'mischief-making microbes, excessive *esprit de corps*; . . . intellectual pride; snobbery; false notions of respectability; . . . extremes of toadyism. . . .'[1] The editors came across some of these microbes in their researches and have included them in an occasional column, which, with acknowledgment to the *New Statesman*, they have entitled 'This Belvedere'.

Finally it should be stated that the book makes no claims to being comprehensive: it does not concern itself, for instance, with any of the achievements of past pupils. Its focus is on what happened within Belvedere during the course of its one hundred and fifty years. In the nature of things, of course, much of school life goes unchronicled: and what might interest future historians does not necessarily find its way into the pages of each year's *Belvederian*. In searching for material for this volume, the editors have been impressed with how much of Belvedere's story cannot be told because of a dearth of

1. (W.G.Fallon), typescript, 'A Catholic Nation and its College Unions', 1928, Fallon papers, National Library of Ireland, MS 22709.

1

evidence: equally, the early editors of *The Belvederian* — it was first published in 1906 — must be complimented for their foresight in inviting contributions from those who recalled their schooldays in the early decades of Belvedere's history. The editors are all too aware of lacunae in this volume. Should readers share this view, and particularly if they have in their possession documents or photographs concerning Belvedere's history, they should consider offering them to a new archive being established by the school to mark this anniversary of Belvedere's history. This should at least ease the task of those involved in marking the bicentenary in 2032!

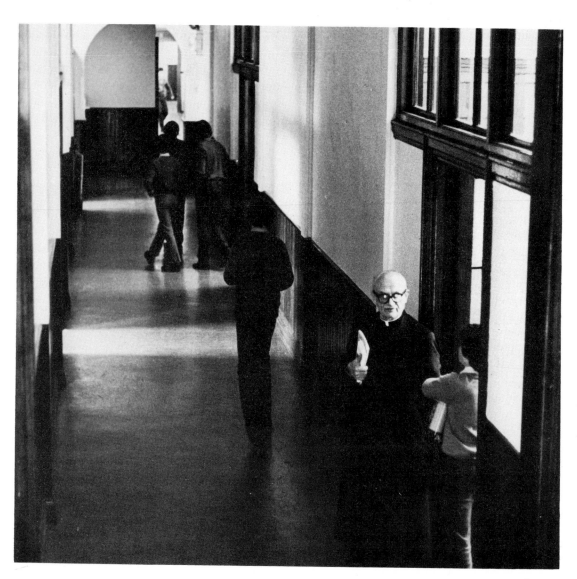

Belvedere House

To mark the centenary of the purchase of Belvedere House in 1941, this essay, 'After a hundred years', was published in that year's issue of The Belvederian.

The stately town house of my Lord Belvedere had been closed for some little time when one day in 1841 a mild excitement was caused in the vicinity by preparation for its re-opening. The neighbourhood had missed the stream of carriages and chairs, the coming and the going of the beauty and the fashion of the polite Society of Dublin City, and was glad to look forward to the pageantry which could be had so cheaply.

It was doomed to disappointment, for when the doors of Belvedere House were thrown open once again, the neighbourhood was treated to the unusual sight of Catholic boys going to school openly — unusual, because Mr O'Connell's Emancipation Act was not so very old, and the former evil days were not far gone when Catholics must creep to their disguised academies furtively and fearfully, lest Dublin Castle lay its heavy hand upon their schools and on their masters.

That was one hundred years ago. Those first Belvederians made their entrance by the Georgian door, and through the halls last trodden by the clicking heels of the lordly host and his modish guests. They were taught in the lofty rooms which had so often seen gay scenes of rout, reception or of ball when my lord and his friends made revelry. If one of those past alumni by some sort of Rip Van Winkle experience should come to Belvedere today, he would not fail to recognise his school at first, but soon he would find himself a stranger. The great hall door is closed to him though the brazen plate announces that the College has not changed its habitat; he would see his fellows trooping in by a gate which had no being in his scheme of things. There was no passage then, for an area surrounded all the house, while now at either side this hollow has been covered in, and entrances so formed, adorned by gates erected in days of Fr Tomkin's Rectorship, about forty years ago. Our friend would join with some timidity the stream of present Belvederians, and on emerging from the passage an unexpected view would open out before him, for the great school building — red brick faced with stone — was not standing when the College opened nor for many a day to come, and the large quadrangle did not then give scope to charging squadrons. Our puzzled visitor would turn towards the old mansion, but no boys

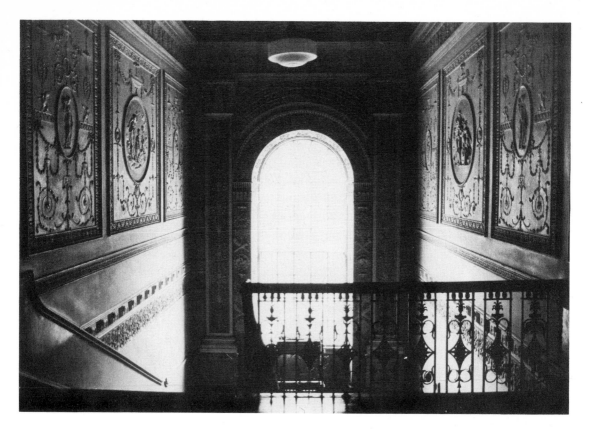

are making entrance there: the ancient rooms adorned by the foremost artists of the day are little changed indeed, but they no longer hear the budding genius or his duller confrère display the fruits of intellectual labours or try to cloak its lack upon occasion. These rooms our Rip Van Winkle would recognise quite easily and perhaps he might recall his strenuous if unworthy efforts to dislodge an inlay of a Bossi fireplace. If he followed those who wend their way at a later hour to discuss the menu of the midday luncheon he might see even yet where others of his company, if not himself, found relaxation in such morbid excavation. This room alone of his Lordship's house is now allotted to the use of boys, the rest are used as reception rooms or dedicated to the use of the Community. My Lord's library is now a chapel, the Apollo room a library, a large room off the hall a Refectory, and the Organ — no spinet for my Lord, i' faith — stands proudly in the room where Diana takes her pleasure in the Chase, King David and St Cecilia still adorn its panels, and Apollo strums his lyre in the space above the manuals.

So far the lines are in familiar places, but outside these everywhere is change. On his exit from the hall to find the garden the ancient one misses the grass plots and the fountain. The former have vanished

4

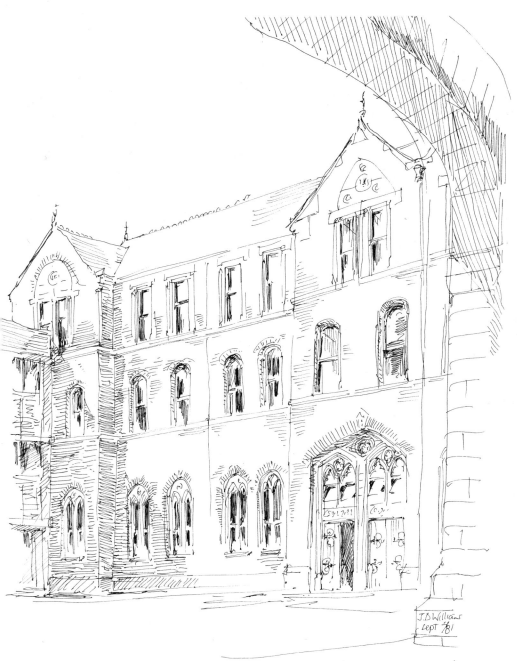

The New College (the Victorian wing)
from the cloister. Belvedere.

5

long ago to yield to a concreted space, while the fountain, surrounded by a circlet of greenery — grass, to be prosaic — held its own till a year or two gone by when it, too, disappeared, to leave the terrain more open for the rushing feet of energetic youth. New buildings there are now to puzzle and intrigue him. On his left a pillared portico — that was built in Fr Quinlan's time and flanks the Theatre put up by Fr Finlay in an earlier era, and a most useful adjunct too, Gymnasium, Lecture Hall and Theatre as occasion offers, it has witnessed many a fine performance from the almost mythical Macbeth of some fifty years ago to the Gilbert and Sullivan productions inaugurated by Fr Glynn in the present generations. If our enquiring veteran should enter and survey the stage he would see upon it that pillared hall of blue which housed the topsy turvy Court of Barataria a month or so agone.

'But soft! we are observed!' Let us advance and lend our kindly aid; yet the gentle reader must be ready for a monologue, for the Winkle voice is faint, it is rusty from want of custom, while ours is burnished to a gleam from plenteous use. Then, in our most stilted accents so as to acquire the proper atmosphere, we take the plunge:— 'There is much to see, good friend, so linger not in wistful gazing at this scene. You had no plays in your days, no football and no cricket, nor swimming nor cycling, nor Treasure Hunts with Cameras, nor Tennis, Rowing nor Debates; but if you have leisure and perseverance you may read of these activities on that array of notice-boards beneath yon green verendah on the far side of the Quadrangle. You were happy without them, you say. No doubt, but do you not approve? You surely must have heard of the *Mens sana in corpore sano* — one touch of the Humanities makes the whole world kin, especially when the touch is a tag like this which groweth whiskers as long as Rip Van Winkle's — Ahem! I mean to say that recreation in due measure is a beneficial thing. You agree? Of course! Well, then, let us proceed. That large building is the College proper. The portion on the left was built by Fr Finlay, the other by Fr Quinlan, and the whole is now the Senior House; for if you have a small brother and he should wake up too, he will find his class in the Preparatory School. "Where is that?" you say. On the opposite side of the Senior House, and it is not a very old addition. You will not know, but the house at the farther side of No. 5 was used for these younger boys once upon a time. Killeen House it was in the older days, and there his Grace the Earl of Fingall would bide when he came to town from his country seat beyond Dunboyne on business or pleasure bent. Many a generation after you and before our time spent their earlier career in the "Little House". It doesn't look so small? Oh no! but the boys were little and so by a feat of transferred epithet we get the required result.

Recalling our attention to Fr Finlay's section of the Senior House you will be interested to know that the large Physics Room occupy-

ing nearly all the ground floor, was the Boys' Chapel for many years. At present the ground floor space of the new building serves for the purpose; it is larger than the old one was and more elaborate in style and ornament. It has been enriched by many gifts of benefactors which you can see immediately on entrance; the marble altar, stained glass windows, Stations of the Cross and Sanctuary lamps. There are other gifts as well, such as a very noble Monstrance, two fine branch candlesticks and several minor articles of use and decoration. There is an organ also which is not quite so ornate as that one left behind in the Apollo Room when my Lord departed, the one you knew; but it is much better suited to the Chapel than his Lordship's instrument could have ever been, even it it could make music now; it cannot, for there came a day, alack! when it joined the Harp of the Minstrel Boy. — I beg your pardon, I'm sure! I refer to a lyric extant long after the epoch of your musical experience. The Harp in question "ne'er spoke again," and neither did the Organ, and there is the resemblance.

Now if we ascend the stairs it is all new to you, and even to a boy of twenty years' absence there are changes in Fr Finlay's building. They would look in vain for No. 8. "What is No. 8"? you ask. It was a famous class where many an enterprising lad spent his days not overstrenuously, for there the thirst for knowledge was not of a kind that demanded copious draughts. I have heard of a wide range of tricks invented by the denizens of this little cosmos, but I shall not utter them in Gath or anywhere else. Perhaps you know a few which were in vogue when your companions practised the gentle art of looking simple, so we shall keep each his own counsel. No. 8 has been incorporated partly in a new Chemistry Laboratory and partly in a corridor. The old Science Theatre has been removed likewise. It had seats in tiers descending to the demonstration table, where the professor would perform experiments for the instruction of his audience, or to their delight if the expected result were not forthcoming.

The remainder of the school building is ideal, i.e., straight halls and rectangular rooms, which are planned for use and not for aesthetic effect, so let us descend, for I think a bell is about to ring, and if you will excuse me I shall leave you, for I have a few small things to do. May I suggest a course of reading at that array of notice boards already mentioned. At this end the J.C.T. — Junior Cricket Team — running then through many interests to the Rowing Notes at the far end. Well, farewell — pray don't mention it. Sorry to go, but I have a few small . . . I beg your pardon! What is a St Vincent de Paul Conference? It is a charitable Society to help the poor in their homes, and the boys, as you see, have two Conferences. Very splendid work! You wish you had had such an opportunity? Recollect that the Society had not been set on foot in 1840. So now if you will excuse me . . .

7

I beg your . . . Oh! What is a Camera Club? Well, a Camera is a "gadget", I mean an instrument for recording pictures. It would be a novel process and take too long to make quite clear, but the other Boards explain themselves. Touring Club, Cycling Club; so with your kind permission . . .

Eh? What is a Cycle? It is a machine on which one rides instead of on a horse: it has two wheels, tandem style, and is called in full a bicycle, and now if you will allow me . . .

One more question? Do the Old Boys keep in touch? They can and many do. There is an Institution called the Union to which many belong. What do they do? — and I was going to add that the Old Boys have a Vincent de Paul Conference, they work a Newsboys' Club and a Housing Society. What is . . . ? and they have a Camera Club and a Golfing Society. Golfing? and under Fr O'Connor's Rectorship, the current period, they have begun a Musical and Dramatic Society. Are they good? What a pity you did not wake up in time or you could have seen their last performance in the Gaiety Theatre. They have, too, a Football Club recruited from Old Boys only which, in Fr O'Connor's time likewise, has joined the Senior ranks and under his skilful guidance has done well. You said? Oh! are they very good? Good enough to win the Senior Cup the last two years. What is the Senior Cup? If you will excuse me, I really . . . One last question! One it must be, for I am in a hurry and you are looking weary as if that long sleep were coming on again. The last question? Are the boys today as good as in your own day? My ancient and highly honoured O.B., that is indeed a poser! for I do not know what you and your friends were like with sufficient detail to give a definite answer, but from what I hear, if we are as good, all's well!

And now, at last, with your very kind permission, as the bell is ringing, I must say "Hail and farewell"!'

Anon., 'After a hundred years', The Belvederian, vol.12, no.3, 1941, pp. 12-14.

The following description of Belvedere House appears in C.P. Curran, Dublin decorative plasterwork of the seventeenth and eighteenth centuries, *London: Academy Editions, pp. 86—87.*

Belvedere House was built by Michael Stapleton for George Augustus Rochfort second Earl of Belvedere, who went into its occupation shortly before 1786. Allusions to owner and architect occur in the plaster decoration. The Rochfort arms show a lion rampant with a bird crest and antlered stags as supporters. Lions appear on the hall frieze and on the double frieze of the staircase, stylised birds are on conspicuous tablets in the Venus room, and the antlered stags are repeated even more notably in lunettes in the Diana room. An

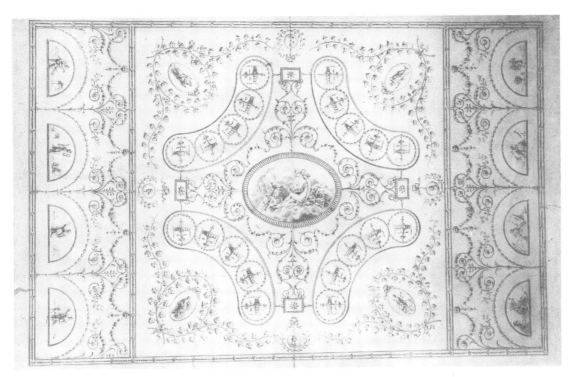

Michael Stapleton, original drawing for ceiling in Venus Room, Belvedere House; undated. (*Stapleton architectural drawings, National Library of Ireland*)

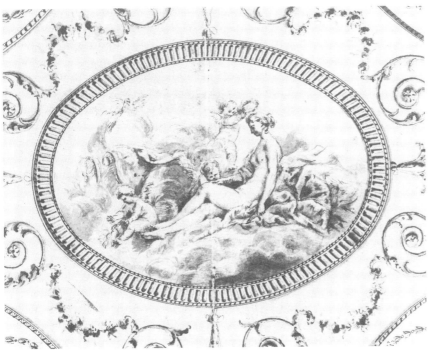

Stapleton's original centrepiece for the ceiling of the Venus Room, Belvedere House

9

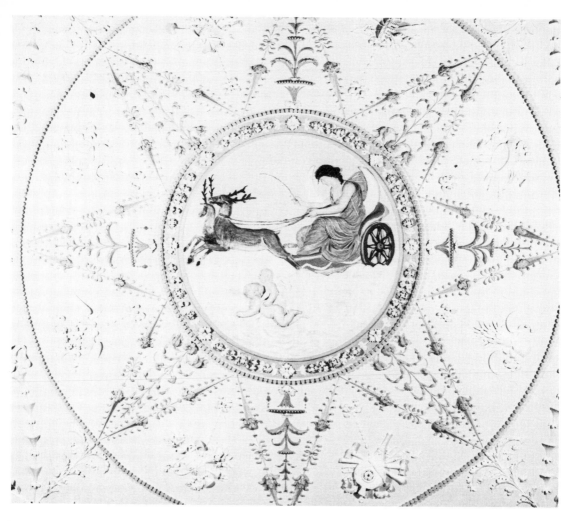

Detail, ceiling, the Diana
Room, Belvedere House.
(*Bord Failte*)

inscription — the only one in the house — is on a small tablet beneath
an oval on the staircase. It is lettered S.A. Roman coins commonly
bore such inscriptions — S.C. (*Salus Caesaris*); S.A. (*Securitate
Augustae*), and Rubens introduced the latter into his Medici series
in the Luxembourg. I make bold to say that here it signifies *Stapleton
Architectus* though I have seen nothing like it in other Dublin building!

As a residence, Belvedere is distinguished by its good disposition
of staircase, landings and fine suite of reception rooms on the first
floor, and equally by its full decoration — the ornament enhancing
the general ordonnance. The staircase is mainly Pergolesi arabesque
with large rectangular panels holding subjects which continually
recur in Stapleton houses. In this house they are most completely
exemplified, sometimes in large scale ovals or rectangles, at other
times in small medallions of allegorical figures, nymphs, bacchantes

10

Belvedere College

The Diana Room (1786).

11

and dancers. The crown ceiling of the staircase has a finely modelled centre-piece of Venus, Psyche and Cupid with eight smaller subjects. On the principal landing there are more such subjects in ovals or circles; a Juno seated on clouds with peacock and sceptre and an Aurora, star-fronted and charioted, driving with uplifted whip her two Pegasi. This popular subject occurs in Richardson's *Book of Ceilings*. Beneath Aurora is a smaller medallion of the Young Bride (*la Jeune Mariée*) taken from the antique marble in the Louvre.

The back drawing room, has a small charming ceiling with a central floral decoration and playful subjects in the circles about it. The Apollo room, now the house oratory, was given over to music. Free-running floral arabesques and medallions in the centre square surround Apollo Musagetes and the end Panels show a variety of other instrumentalists, flautist, 'cellist, tambourinist, lute player, drummer and conductor. The Venus drawing room presents an admirable scheme of well controlled ornament; classic and natural-istic ornament gracefully blended in the main area, and Pompeian themes in the end lunettes figuring children at play, as we have already mentioned. Ingeniously connected with it, the Diana room is more remarkable by reason of its vigorous modelling and its more complete departure from the contemporary Adamesque. Its prin-cipal subject is Diana charioted by deer in circular and pointed frames again diversified by the intermixture of the arabesque and the naturalistic. I have already alluded to the commanding lunettes in this room with the stags taken from the Rochfort arms. They are unmistakably borrowed from a seventeenth century design by Bérain much as Picasso centuries later took other Bérain inventions with which to dress up for Diaghilev the two managers in *Parade*. Less remote are other details on this ceiling. Associated with hearth and home, agriculture and the sea, war and the chase, we find bellows and tongs, wheatsheaves and sickle, trident and oar, drums and trumpets, stag's head, spear, birds and arrows. . . .'

Stapleton is never other than orderly. This sense of order has imposed a unity on Belvedere House that is not so evident in West's varied work at Dominick Street or St Stephen's Green. If Stapleton's decoration of the former house lacks the idiosyncratic stamp of West it has its own perfection. It offers a full conspectus of our house decoration in the Grattan period and with Powerscourt House and Lucan House presents Stapleton as the master of our silver age.

12

Belvedere in History

OWEN DUDLEY EDWARDS

An old Belvederian who undertakes to write a sketch of the history of his school must find himself brooding over *A Portrait of the Artist as a Young Man*. Such was James Joyce's almost incredible obsession with self that he provides more fully than anyone else a sense of what it was like to be at school in Belvedere, although the sharpness and economy of the sequential episodes of the *Portrait* distract us from the historical reality that school life is evolutionary, not episodic.

Joyce attended Belvedere from 1893 to 1898; my own time there was from 1950 to 1955. Reflecting on the periodisation of the school's history, I want to suggest a unity linking these dates. In the Belvedere of my youth, Joyce was definitely unmentionable, as the blasphemous, sex-obsessed defiler of the Church he had betrayed. Today Joyce, as a witness, as a cold but not a hostile mind, compels more respect than almost any other memorialist of Belvedere.

My argument as to the unity of Belvedere history between Joyce's time and the 1950s arises from fairly general impressions in reviewing the evidence available, but the case becomes clearest when we look at the terrain on either side. The modern side of that period of unity is marked by the Second Vatican Council and the currents to which it responded and which it set in motion. On Belvedere, as on so much else in the Catholic world, the process was a revolutionary one. I welcome much of what that revolution entailed, but I see in the new Belvedere something radically differing from mine in ways where Joyce's did not contrast with mine at all.

Belvedere from its foundation under the Rev. C. Aylmer, S.J., in Hardwicke Street in 1832 until the arrival of the Rev. T. Finlay, S.J., as Rector in 1883, is the story of a small and unpretentious city establishment, chiefly preparatory, its status rudely summed up in the parody boys used to make of the description of Purgatory in the penny catechism:

Q. What is Belvedere?
A. Belvedere is a place or state of punishment where some Jesuits suffer for a time before they go to Clongowes.

13

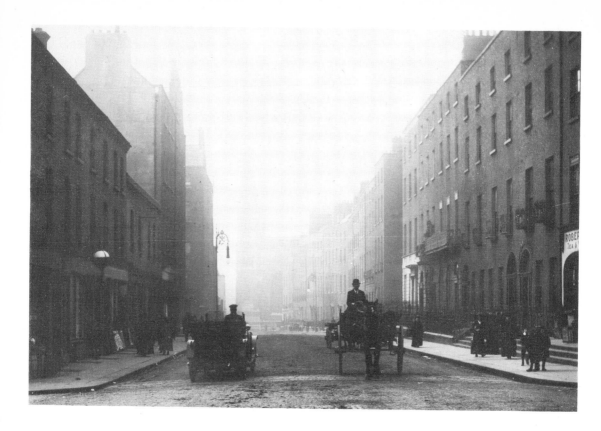

View of Great Denmark Street, Dublin in the early years of the century. (*Lawrence Collection, National Library of Ireland*)

The very physical existence of the school within Belvedere House itself until Finlay's Rectorship symbolises the special circumstances of those formative years: small groups of little Catholic lower middle-class boys imbibing elementary education in rooms designed for the delectation of a caste far removed from them in wealth, morals and religious persuasion. It is also extremely difficult to set a character for Belvedere within the period: to be sure some of the boys became doctors, and some became journalists, and some became Jesuits, but for the most part they were like their ancestors (and some of their contemporary near relations), nomads: Belvedere was but a stepping-stone to most of them, and the most eminent figures in the Old Boys' Union were frequently also graduates of Stonyhurst, or Clongowes, or occasionally European institutions, or indeed might have served out the remainder of their schooldays under Pharaohs who knew not Ignatius.

Between Joyce's time and the 1950s the island saw the Irish Renaissance, the Irish Revolution, the Anglo-Irish and Irish Civil Wars, the Cosgrave regime, the de Valera years, the declaration of a Republic, also the Boer War and the two World Wars, and much of their impact on the character of the institution was superficial.

14

This is decidedly to the credit of the institution, in most respects. It induced a tranquillity, though not a complacency, of mind: the Jesuits, knowing their own Society had once been abolished for all time, developed an extraordinarily invisible yardstick. It was not simply an implication that the temporal world became of little account when considered *sub specie aeternitatis*; it was that a temporal sea which had smashed and destroyed them in its time was singularly irrelevant in its flows and ebbs after their Society had arisen from the dead. How much of this was rooted in the early years of Belvedere, and shaped its subsequent development, we simply do not know, and may never know. For one thing young Belvedere, as with young Stonyhurst, young Clongowes, and the rest of the much more pretentiously established Jesuit institutions, had problems of identity: and so low did Belvedere stand in Jesuit and lay educational priorities that it must have suffered much longer than the rest from that identity crisis. After forty years of suppression the new Jesuits had to create a new identity for themselves, patterned on a cruelly broken tradition. The Ireland in which Belvedere was founded was itself in a state of flux, with the O'Connell movements having given a new dignity to its Catholics; yet the Dublin in which it grew up was at its historical nadir. As Dublin slowly recovered from being plunged after centuries of capital status into that of a provincial centre, Belvedere grew with it. The hour produced the man: the man was Tom Finlay.

Finlay was one of the most extraordinary men of a truly extraordinary time — the Irish Renaissance — yet today he is in danger of oblivion. As educator, writer, administrator, economist, politician, agriculturist and Heaven knows how much more, he was pre-eminently the Renaissance Man of the Irish Renaissence. And the Belvedere he built in the 1880s was both a physical building and an invisible character. The word 'building' employed in this sense is much more literally true of Finlay than it is of patrons or architects whose activity remains strictly limited to design and supervision: Finlay from time to time did his bit with the bricks and mortar.

Although Finlay's term as Rector of Belvedere was relatively short, his influence dominated the school throughout his long life which ended in 1940, and by examining a little of his work and ideas we come closer to understanding the ethos imposed by the school. Finlay was an unassuming man, many of whose writings were unsigned, but some of these have been subsequently identified. From looking at one of the anthologies he compiled for school use (and his industry churned out grammars, arithmetics, primers of all kinds as well as papers on educational theory, treatises on economics and popular philosophy and political science through the periodical *The Lyceum* he ran in the 1890s), we get a sense of his priorities. In part these were dictated by the state certificate curriculum, but in part very

Fr Tom Finlay S.J.,
Rector, 1883-88

clearly by private sympathies. It is clear that Finlay reflected that
multi-directional set of pulls Joyce captures in 'The Dead' where one
can see Ireland fumbling for a culture, uncertain between Europe,
Rome, London, the Gaelic West. But he was deeply aware of the
new Ireland and the priorities it would require: and he intended to
train its ruling class. He was concerned with turning people out for jobs
which would have to be eased away from the grasp of the Protestant
elite which once monopolised preferential positions; and to the end
of his life Finlay was deeply suspicious of attempts which might be
made to preserve economic and social monopolies among special
interest groups. For these reasons he campaigned very hard against
the Freemasons, and while he used the religious character of Free-
masonry as a means for showing its unacceptability to Catholics, his
target was the economic exclusiveness and favouritism of the move-
ment. It is logical to add that concern about Freemasonry has fre-
quently induced imitations of it: Old Belvedere had a decided touch

16

of socio-economic exclusivism about it, a strong flavour of seeing in itself a chosen people. In a sense, Old Belvedere acquired a distinctive character before Belvedere itself did. Because the school was in Dublin, an Old Boys' Union meant more for ex-Belvederians than it did for old boys of institutions in the heart of the country or outside the island altogether. Hence Old Belvedere rallied to its call troops whose Belvedere experience had often been decidedly shorter and more juvenile than their time in more (or indeed less) eminent academies. And of course, to be realistic, one of the major origins of the Belvedere Union lay in the valuable business and professional acquaintances it provided.

Finlay and the generation he inspired were not simply concerned with takeover of power: the new Ireland they planned was intended to differ in quality from the old. For one thing, Belvedere had a strong philosophy of hostility to the State. Voluntarism was very deeply stressed, and co-operation among individuals at all levels. A social club was established for the little ragged boys who sold newspapers on the Dublin streets and a moribund philanthropic committee of the Belvedere Union was ultimately induced to take over the Newsboys' Club with the schoolboys themselves being drawn in to assist during their senior years. The question still remained whether the civilisation which made such a club necessary was to be congratulated: certainly Finlay's socio-economic dreams posited a dynamic society, not simply a negative and static one.

The spectacle of the schoolboys ministering to poor boys of their own age forced to work for their living, raises questions as to the social position and ethos intended for the Belvederians. Belvedere has been called a 'snob' school, but it would in some ways be fairer to call it an 'anti-snob' one. As we have noted, it came surprisingly lower in the social pecking order than many. It was not a 'public school', although Clongowes was. The intention that young Belvederians would inherit Irish leadership partly involved a conviction that existing leadership derived too much from an effete aristocracy, an alien caste system and a set of snobbish values degrading to humanity. Because Belvedere was lower down the social scale than Clongowes, it was all the more critical of existing snob priorities. If it made much of William Martin Murphy and his material success, it did so partly while celebrating his refusal of a knighthood from the visiting King Edward VII and while at least being highly conscious of his sing-song Cork accent with its 'd' for 'th'. ('And dey make Popes out of dem', he sneered once at some Italian workmen of his who had failed to move a great stone at his command.) Simon Dedalus, probably correctly reproducing John Joyce, spat that the Christian Brothers produced 'Paddy Stink and Micky Mud', and that his son at Belvedere would be saved from that: and it is important that Belvedere, like its rival Blackrock, would pride itself on its superiority to the Brothers.

William Martin Murphy

The war between Joyce's defenders and traducers has led to a common assumption that he rebelled against the Jesuit mind for which he was too profound or too unworthy, depending on your perspective. Actually, Joyce is much more the faithful son of Belvedere than either of these views comprehends. The Jesuits gave him a European sense which was to be one of his most distinguishing characteristics and he was genuinely affected by the classical atmosphere of the place. Joyce deeply appreciated the Jesuit enthusiasm for classification, order, arrangement: Finlay believed in taking the boys through associations of ideas, reading first Macaulay on Boswell or Burke, and then progressing to the eighteenth-century writers themselves. But there would also be an Irish dimension, not one to suffer by comparison, but to restore self-respect. Curran, Burke,

Grattan and O'Connell would be studied as examples of oratory in addition to Walpole and Pitt; Goldsmith, Steele and Moore would take proud places among the British authors.

Finlay and his generation had to come to terms with the degree of Irishness they saw desirable. In this sense the Jesuits differed from on another very decidedly in their loyalties. The very close links with Stonyhurst involved experience at the Lancashire school for many Belvedere teachers, and they would have imbibed some of the acceptances and rejections of English priorities which characterised that institution. The Stonyhurst link diminished with the establishment of the Irish Free State, but it persisted: for instance, Fr Charles Byrne brought youthful Stonyhurst experience, and intonation, to the senior Latin class at Belvedere he was still teaching in the 1950s. (In his case this carried with it a cheerful Wodehousian form of invective, whereby delinquents were told to write out so many times 'I am a mangold-wurzel' and similar epithets. It also was reflected in his life-long devotion to Gilbert and Sullivan, which took the place of the older tradition of plays when he established the school opera in the 1920s and maintained it throughout his time. Yet there was no surreptitious crypto-monarchism about Charlie Byrne, save in the conviction of everyone who dealt with him that they were encountering the finest and most courteous type of English gentleman.

But the pull of Gaelic and of Irish patriotic sentiment became of increasing relevance from Finlay's day onward. The Rev. Lambert McKenna, the Jesuit lexicographer, was briefly Prefect of Studies, and his influence later reflected itself in the establishment of Irish classes at the end of the first decade of the century. (At the same time, but unconnected with them, was a young lay-master of mathematics, named E. de Valera: ironically his political regime from 1932 saw the decline in the influence of Belvedere in Irish public life, Blackrock and the Christian Brothers coming to the fore in its place.)

The Jesuits were in an interesting situation as regards the development of Irish nationalism before 1916. They were careful to invite leaders of the Irish Parliamentary Party, such as Redmond and Dillon, to public functions, but links with party rebels who would later make terms with Sinn Féin, such as Tim Healy and William Martin Murphy, were decidedly stronger. Another Belvederian was Joseph Mary Plunkett, whose father would strike the first nail into the coffin of the Irish Parliamentary Party by defeating it in the first by-election after his son's execution following the Easter Week Rising of 1916. Finlay's activities with the co-operative movement involved their own implied criticism of the party's jobbery and favouritism. Cathal Brugha's Belvedere origin reminds us of how extreme some of the school's products would become; and *The Belvederian* saluted his rise to celebrity in the years after 1916

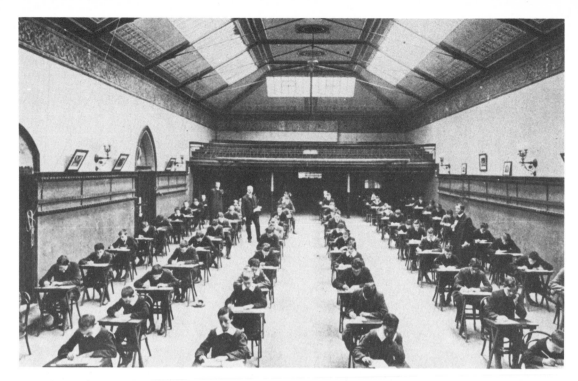

Examination Hall

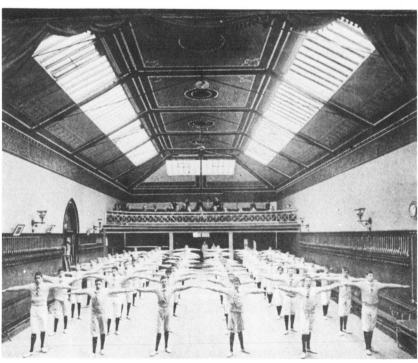

Gymnasium

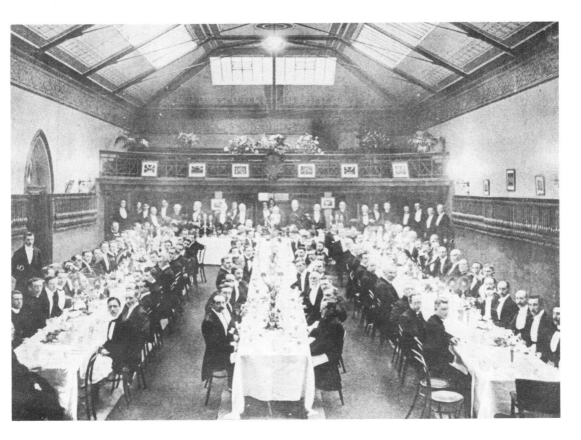

First Union dinner, 1902

with a somewhat vague enthusiasm, although his death in action at the beginning of the civil war was greeted in its columns by an ominous silence. But in fact the most famous of all Belvedere martyrs, the very recently graduated Kevin Barry, tells a somewhat different story. Barry's fame in Belvedere was as a persevering and conscientious Rugby player who by sheer grit fought his way to stardom in the Senior first fifteen, and with his execution the hotbed of rebellion in Belvedere was the Rugby crowd, past and present. It underscores the ambiguity of Belvedere's situation that extreme nationalism at its height was so closely identified with a game denounced by so many followers of the new Irish nationalism as 'foreign'.

The most serious question for the historian of the Belvedere of Finlay, Joyce, Byrne, Brugha and Barry must be the extent of intellectual inquiry, and the limits placed on it. Clearly, for all of the heady ideological atmosphere of those years, the Jesuits preserved largely a cool and anti-emotive tone. The atmosphere, then and later, was one more of a master-pupil conspiracy of irony rather than the crass indoctrination of crude nationalism which would

21

characterise the Christian Brothers, or the more sophisticated but still unquestioning crusade mentality of Blackrock. Eugene Sheehy's recollection of a boy named Lenehan trapping the then Rector, Father Henry, as to whether a specific quotation existed in a book (which he had illicitly been consulting during a memory test), concludes with the Rector handing in 300 lines, and the episode shows a common enjoyment of irony as well as a commitment to justice. That sort of thing made for a school which maintained generally though not invariably a quality of self-mockery which could prove a valuable safety-valve in future years. But how far were these ironies permitted to go? J.F. Byrne has a disturbing story of novels being banned after a complaint from a boy's family that *Ivanhoe* was being read, and the previous diet of Lord Lytton and Walter Scott was abruptly discontinued. This seems difficult to equate with the spirit which Finlay had been seeking to build up, but whatever its individual accuracy it reminds us that the Jesuits were no more immune than any other Irish clergy to vulnerability before obscurantist pressures from laymen with bees in bonnets.

In the teaching of boys the famous hell-fire sermon in the *Portrait* owed much more to the boys themselves than is realised; horrific stories of martyrdom also were invariably popular. What the Jesuits had clearly not anticipated, however, was that such cults of martyrdom were to work their fullest effects, not in the cause of Catholic education but in that of nationalism, the British and the Irish varieties. For the most part the Jesuit teaching discouraged excessive enthusiasm: vocations were not desirable unless subjected to severe personal intellectual scrutiny. ('Have you an aunt who's a nun?', remarked Father Tom Counihan to at least one schoolboy who imagined himself on the road to the priesthood.) There was never any real danger that boys who did not state intentions of seeking the priesthood would find themselves second-class citizens, or that those who did and later dropped out would be blighted as other 'spoiled priests' often were. The emphasis on a Catholic laity as the chief objective of the school was much too explicitly stated for that. The system of masters specialising in individual subjects as opposed to actual form-masters increased the safeguards here; good relations between masters and boys were encouraged, but not such that one master's influence would dominate a boy's life to the exclusion of all others. Hence an individual Jesuit who might be excessively concerned to win recruits to the Society would not overshadow his charges' horizons. It also meant that bad relations between individual masters and boys could only have a limited effect, which was a good insurance for the masters as well as for the boys.

One of the most interesting examples of training an articulate laity was that pre-eminently associated with a man who may well have made more impact on Belvedere than any person save Finlay,

22

Fr John M. O'Connor S.J.

and whose personal links with the school lasted far longer: the means was debating, and the man was the Very Rev. John Mary O'Connor, known for almost the first sixty years of the twentieth century as 'Bloody Bill', a designation which sums up both the force of his character and the affection it elicited. In his prime he was evidently tremendous, and it is a pleasing irony that his initial association with Belvedere was having to be removed from it as a boy in the late 1880s because of his uncontrollable spirit after school hours. He returned as a scholastic in the first decade of the new century, minus an index-finger (whose absence prompted an impressive variety of apocrypha over subsequent generations) and promptly threw himself into the work of establishing a Debating Society, organising the Swimming Gala and ensuring the purchase of the Sports Ground at Jones's Road. There had been virtually none of the extra-curricular form of directed activity before Finlay: after the advent of Bloody Bill, it was scarcely possible to imagine Belvedere without it. The school became an intensely 'clubbable' one, rivalling universities in the range of hobbies and interests it cultivated. He could be the toughest of mentors, and on his return to Belvedere as priest in 1921 practically hurled the school to the forefront in Leinster school cricket and Rugby football by sheer force of personality. He thundered his adjuration with all the inherited zeal of the offspring of a

Parnellite Lord Mayor of Dublin, and though his incessant hold on the attention of his audience by the invariable 'd'ye follow?' was the delight of an endless succession of small mimics, he did have an extraordinary sense of when to be gentle. Bloody Bill served as Rector from 1936 to 1942, and finally returned again in 1947 shattered in health and still indomitable in spirit, to die eleven years later. *The Belvederian* obituary could not, of course, mention his nickname — the sanguinary adjective was still accounted profane in the 1950s — but the obituarist, with more fidelity to the principle of the Jesuitical than is commonly found in that much-abused Society, got round it by a comment on the date of his demise. 'And when the end came there was a certain humour if we may be allowed to put it that way, in that he was called to the other life not on his feast-day of St John but the very next day, the feast of St William.' One gets a sense of the freedom of inquiry before the First World War, and the restrictions on it afterwards, by noticing the subjects for debate. In the first year the Rhetoric Debating Society disputed whether Irish should be compulsory in the newly-founded National University, whether a State benefited by conscription, whether women should have the vote, professionalism in games should be condemned, railways should be nationalised, modern languages were more advantageously studied than classical, the existing system of education was beneficial to Ireland, Republicanism was preferable to Monarchy, the Irish Parliamentary Party merited the support of the Irish, Protection was preferable to Free Trade, a surprise attack on England by Germany was impossible and 'That the Spread of Civilisation in the East is a Menace to the Security of Europe'. This was, to put it mildly, a birth for Belvedere debating in thunder, and fully reflects the ebb and flow of debate on so many questions in the adult world of the Irish Renaissance. Moreover, it was very courageous for its time.

Clearly Bloody Bill had no intention of founding a society for intellectual mollycoddles. He had the advantage of a splendid senior year, headed by his auditor, Arthur Cox, afterwards the greatest Irish solicitor of his day and by common agreement the most brilliant student Belvedere had ever known. He was succeeded as auditor by George O'Brien, a choice on Bloody Bill's part which says everything for his analysis of character, intellect and hidden potentialities. That year they kicked around world disarmament, old age pensions, a universal language, the abolition of dramatic censorship (an English, not an Irish, phenomenon), the payment of MPs, the detriment of patriotism to progress, the party system, Socialism, the value of reading fiction, vivisection, and the dangers of urbanisation.

Official debating lapsed during the Anglo-Irish war. Night meetings were far too dangerous and so, for that matter, were debates. Bloody Bill revived them on his return, but the holocaust of 1914—23

curtailed the options of the new future. Freedom of the press was debated, and immigration of aliens, and censorship, in the mid-1920s, the new stresses on inhibition of liberties being ominous signs of the new times. The choices themselves reflected Bloody Bill's interest in alerting his students to topics of the day, and finding a far livelier method of teaching the civics barred from the official curriculum by a cautious and conservative state system of education. But it was a reminder that an adventurous Ireland had given way to a frightened Ireland.

The school prize essays had gone in something of the same direction, in that the years before 1914 showed a heady Anglophobia albeit largely confined to constitutional questions such as the careers of Grattan and O'Connell. (The juniors were given seemingly less complex subjects such as Owen Roe O'Neill or Brian Boru, blocks for whose illustrations were kindly lent by William Martin Murphy). This matched the boys attending the unveiling of the Parnell monument on 1 October 1911, to return yelling joyfully 'We *want* Home Rule! Ireland *must* be a Nation!' The advent of war cordoned off this field of scholarly research and expostulation, the English prize essay being on Goldsmith and the Irish on the Volunteers (with firm expressions of support for John Redmond's commitment of the modern Volunteers to the British Army). After that subjects stayed literary for the duration of the war, but at the hightide of rebellion after Kevin Barry, nationalism returned with a vengeance, the topic for the winning entry being the Cromwellian Plantation in Ireland.

In any case, as the school magazine had apprehensively noted after the Easter Week Rising, Old Belvedere was deeply divided by what had happened. Joyce, in Switzerland, regarded the entire thing as designed to annoy him personally. Austin Clarke very much followed the prevailing political wind in the aftermath of the Rising, adding his own offerings to the Plunkett shrine. William Martin Murphy, after demanding the head of his old enemy James Connolly when the 1916 executions seemed halted, became identified with the new nationalist establishment. The Dillon sons kept a lonely vigil beside the ruined shrine of their father's defeated Parliamentary Party. But the school firmly committed itself to the new state, and the very first issue of *The Belvederian* which declined to take note of the death of Cathal Brugha symbolised its new commitment by editorial and roll in English and Irish.

Irish had been on and off in Belvedere for years, and now it was definitely on. It was Belvedere's misfortune that, being popularly regarded as on the wrong side in politics from the moment its former mathematics junior master came to political power in 1932, it was subjected to the sneer of 'West British' from the followers of the new regime. Yet on the issue which meant more to de Valera than partition,

the Irish language, Belvedere built up a powerful intellectual tradition.

But the role of Irish masters in these years carried its own heart-break. Séamus Ó Murchadha and Tadhg Ó Murchadha, in particular, had embarked on their careers with a great sense of vocation, and a conviction that the language they loved was at last to come into its own. Coming to Belvedere, as they did, in the 1920s, their teaching lives spanned the erosion of the language policy until by their retirement it had become an empty shibboleth largely useful for the humiliation of a former elite unacquainted with its workings, or laboriously condemned to parrot it.

Yet for all of that heartbreak, Tadhg and his colleagues kept the spirit of Irish alive in a school otherwise cynical about official patriotism, a cynicism in which he largely joined. What Tadhg succeeded in doing was in building for his pupils a massive infra-structure of understanding of Gaelic civilisation and culture in the modern period. He could convert the most Philistine of his charges by the elegance of his sarcasms, and the industry he put into the explanation and dissemination of idioms carried its own infection. He was clever, also, in getting Irish to the younger boys by opening the Irish debating society to them. English debates were restricted to the seniors, but all were welcome, however inarticulate, at An Cumann Gaedhealach.

Above all, Tadhg, for all his firm insistence on attentiveness in class, had a great deal of the schoolboy in him: he and his colleague Danny Morrissey were known for packing soup-plates in one another's suitcases with subsequent moments of truth in class, much appreciated by their charges.

On the role of sex in Belvedere it is impossible to speak with any certainty at all. The Jesuits normally practised a very careful agnosticism as to what took place outside school hours and school events, although such agnosticism might prove highly illusory when it was a matter of overlooking the absence of fee-payments because of parents' actual inability to meet their obligations. Gradually boys came to realise, without resentment, that far more was known of their home lives than they had ever imagined: and that knowledge was generally only employed when it was necessary to do so.

But boys' sexual stirrings were matters for the confessional. The subject was virtually never mentioned in my time. One boy sarcastically remarked that so important a subject could only be dealt with in the sodalities, that in the St John Berchmans' Sodality 'you're too young', that in the Holy Angels' Sodality Fr Schrenk, the universally respected Sudeten German in charge, couldn't be expected to know the English words, and that in the Sodality of the B.V.M., 'you *should* know'. At one point the Rev. Michael ('Tosh') Maloney became aware of and vociferous about 'wolves in my flock, dirty

boys, peddling dirty magazines'. Unfortunately the school in unison immediately decided that this referred to the most officious prefect of the year and he was followed for weeks by small boys shouting 'X! X! Wolf! Wolf!' That more or less finished sex in Belvedere in my day until the appalling occasion when an American Jesuit, Sweetman by name, appeared demanding that he make an address to the boys. And what he wanted to tell us was that our sodalities were sinks of filth and iniquity. We might have succeeded in fooling Father Rector, we might have succeeded in fooling Father Prefect of Studies (surreptitious glances stole towards the Rev. Rupert Coyle whose massive, leathery countenance told us we'd be ill-advised to try), but we couldn't fool the speaker. He knew what we were up to in our sodalities. All boys were the same, and we were no better and no worse than American boys, and there was no point in coming on all over innocent, because he knew what we were up to with girls. He would give us examples of the practices which were common in American sodalities. (At this point several persons took out note-books and pencils, caught Rupert Coyle's eye and hastily put them away again.) There was keeping company. This involved walking out with girls, petting them, cuddling them, embracing them in improper fashions and in improper places (he was not, apparently, being topographical), and he had asked these girls what happened, did they sin or did they not sin, and one girl said, yes Father, most of them sinned. And another said indignantly, no Father, only 50 per cent of them sinned. So he was going to eradicate this practice here and now. By this time most of the school were bursting with ill-concealed giggles, several were all too closely interested, the lay-masters were stuffing handkerchiefs in their mouths and the Jesuits were looking as though they had swallowed pokers in their entirety. Eventually the speaker drew to his close, promising action next week — which never eventualised, though Heaven alone knew what its extra-mural consequences were — and the Rector offered up a prayer which was understood to include the hope of immunity from a like visitation in future times.

All of this was in the post-war era, and the Second World War, like the First, had something of a critical impact on the mind of Belvedere. The College gave several of its old boys to military death in the Allied cause. It gave many more to the armed forces of the Irish state during the 'Emergency'. And the tradition of militarism which had produced such figures as the nineteenth-century Belvederians in the British imperial service, the Willie Doyles, the Joseph Mary Plunketts, the Kevin Barrys, reasserted itself in even less healthy ways. Conscious as it was during the 1930s of the loss of its hoped-for power and influence, with the advent of de Valera to power, Belvedere's discovery of European counterparts was one of the less happy consequences of its traditional internationalism. Italy

was the grave danger to Irish belief in democracy in these years, more particularly after Mussolini had entered the Papal favour with the Vatican Treaty of 1929.

As early as 1927 a Belvedere group had gone to Rome and got itself photographed with Mussolini, about whom it made noises of vague goodwill. Had Mussolini been Greta Garbo the group would have wished to be more enthusiastic, and the priests would have wished them to be less, but not for any reasons of favour for Mussolini. In the 1930s Belvedere seems to have avoided Fascist temptations of the Blueshirt variety, or the anti-Semitic witch-hunters headed by Rev. Denis Fahy, C.S.Sp., but Belvederians were associated with the idea of a Christian Front, notably the Belton family, Niall Brunicardi and others. Behind the Catholic and Christian Frontism lay another kind of nationalism, although they were quick enough to condemn formal nationalism of the de Valera variety; the insistence on declaring Ireland a Catholic nation and doing so with little allowance for other religious traditions and expressions of belief within the state, completed the eradication of English influence. By reducing Irish Protestants to the status of invisible persons in the demands for a Catholic country — and in the 1930s these demands abounded from the school, its old boys and its most famous products in public life — the final tables were being turned on the age-old British treatment of Catholicism.

It is still possible to see a unity to the Belvedere Middle Ages (1883–1963) even from the nadir of inter-faith relations after the Second World War; the beliefs of Finlay meant fighting for positions for boys in the professions, whence Protestants had so long excluded them, and against inheritance and privilege. Belvedere demanded that its sons produce the professional leadership many of them did, although it may have been surprised by the number who evinced literary preeminence (Joyce, O'Riordan, Eimear O'Duffy, Plunkett, Clarke, Denis Devlin, Myles Dillon, Gogarty).

The international perspective established over the previous century played its part, too, in giving the new generation a global sense, such that Garret FitzGerald was almost certainly more versed in the internal affairs of all the member countries of the EEC than any of its other premiers.

If we turn back to those old debates of Bloody Bill, it is fascinating to see in 1909 the concern with nascent and indeed traditional Irish issues, but also with current British ones, such as nativistic fear of alien immigrants or German invasion. In 1909 Ireland was a 'two-tier' country; her loss of one tier made for parochialism, introversion, self-protection, censorship and loss of confidence. Yet through international consciousness a new two-tier society emerged. It may in certain ways be a revoltingly materialistic one, and the Jesuits of Belvedere have to confront the thought that with the

collapse of social sanctions demanding religious observance, the religious training in the school itself will not hold all, perhaps not even most, of Old Belvedere to the old faith. This in its turn asks the salutary question whether the years of religious fervour were really much more than a formal expression of social respectability, and for this reason the Jesuits have cause to congratulate themselves on insisting at most times on intellect rather than emotion, aesthetics rather than enthusiasm.

Is there such as thing as a Belvederian? I have suggested that, save for some original members of the Old Boys' Union, founded early in the twentieth century, the period before 1880 lacks a recognisable profile, given the many other schools, and the brief Belvedere careers, of many of the pupils. Of course even the smallest term of attendance may leave its mark (and the largest leave virtually none), and an emerging Ireland would owe much to such very different figures as the lawyer Christopher Palles, the capitalist William Martin Murphy, and the doctor Francis Cruise. But it is Finlay's ideological work, no less than his quadrangle, his schoolrooms and his gymnasium, which stamp the Belvedere of the twentieth century, and perhaps because it did not have excessive social pretensions, was hostile and uneasy to any preciosities, cultivated a realistic common mockery between boys and masters, it assisted the development of hidden aesthetic ambitions among the James Joyces and Denis Devlins. The work of the Newsboys put it in some danger; a greater awareness of poverty might yet lead to assumptions of natural class and social divisions by reason of birth, but it also reminded the schoolboys that the hold on the prosperity of the religious caste whence they came was a slight one, and that there was no virtue in it.

It could have awful moments of bathos — the number of unspeakably dreadful school exercises solemnly described by their infant authors as redounding to the greater glory of God (A.M.D.G.).

It could not, in many instances, claim to remould its pupils in major degree; contrary to popular mythology, the Jesuits have no reason to wish to supplant the home environment since the ideal education of a Catholic child should depend on a Christian home. The Jesuits were very anxious to avoid surrogate parenthood, and in Belvedere the principle of a day-school, even with returns for evening social events, militated absolutely against any suggestion of the child being 'in the hands' of the Jesuits.

What it did involve was an enormous storehouse of altruistic dedication by Jesuits and lay-masters, and an impressive collegiality among boys, without anyone getting particularly maudlin about it. That altruism and that fellowship are not easily equalled, and the results are shown as truly in the Jesuits celebrating the Sacrifice of Jesus Christ on the altar as in the author of *Ulysses* vindicating God's

creations in their affirmation. Old father, old artificer, stand me now and ever in good stead. A.M.D.G.

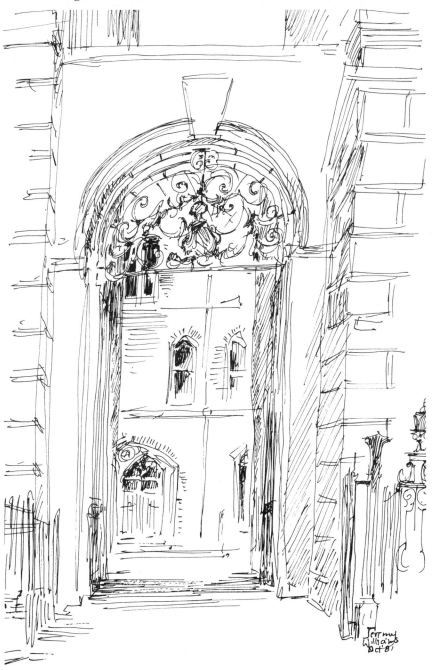

Entrance Belvedere College

THIS BELVEDERE

I

Go, prosper little book! within thy page
Be mingled hopes of youth and saws of age,
 Let Wit and Fancy through thy cover run,
In frolic harness with Experience sage.

II

Bring back remembrances of boyhood's years;
Their dreams and disappointments, joys and fears,
 To those who, like myself, their memory
The name of Belvedere in age endears.

III

And while at times across the ocean's foam
For scenes and sites contributors may roam,
 'Midst Eire's chronicles of clay and stone
Let Irish pens work lovingly at home.

IV

With gentle, too, and not unfrequent hand,
Her blotted leaves of history expand,
 That Irish youth may learn to know and keep
The duty owed to Faith and Fatherland.

<div align="right">

RICHARD PAUL CARTON
(1848)

</div>

The Belvederian, *first issue 1906*

What of the feeling about Belvederian 'snobbishness'? We would suggest that in this case as often, the term is wrongly substituted for 'gentlemanliness'. For we would affirm, with all modesty, we hope, that while occasional rowdiness will appear in Belvedere as elsewhere, yet in general *Gaedhealachas* (in the Irish sense of *tuatachas* or boorishness) is as alien to the school as is — to coin an antonym — *Sasachanas*. There is one quality which we have ourselves observed in Belvederians, Old and New — call it 'poise' or 'gentlemanliness' or 'courtesy' or 'snobbery' as you will — it is a certain assurance which is free from arrogance, a politeness which is void of ostentation. To sustain our opinion this comment has reached our ears from so far away as the United States of America: 'That Belvedere School turns out men who can speak.'
Editorial, The Belvederian, *1945.*

RELIGIOUS INSTRUCTION

Death — Our new school year another section on our journey towards it — perhaps the last.
Extract, The Belvederian, *1918.*

32

Schooldays 1832-1899

FRANCIS R. CRUISE

*Sir Francis R. Cruise, first President of the Belvedere Union,
contributed to the first issue of* The Belvederian *in 1906, some
reminiscences of his years as a schoolboy in Belvedere from 1844 to
1848. He recalled this anecdote about Fr P. Meagher, the then Rector.
Fr Meagher, he found 'austere in manner, and taciturn; but warm
and sympathetic in heart, and not devoid of a certain quiet humour'.*

Good Father Meagher loved the boys, and won their affection and
esteem despite his exterior reserve, and he was ever ready to take the
part of anyone in trouble. I will here relate a little story to illustrate
his character.

One day a very fine lady called to consult him confidentially about
a great trouble which weighed heavily upon her soul.

Awful to relate she had discovered that her dear son was actually
in the same class with her baker's son!

'Let me hope, dear Father Meagher, that you will take precautions
that no undue intimacy shall arise between these boys.'

'Make your mind easy, dear Madam,' quoth his Reverence, 'it is
true that the boys are in the same class, but, as the baker's son is
always at the top, and your son equally punctually at the bottom,
you need not apprehend any close intimacy arising between them.'

The lady retired, silenced if not comforted.

Francis R. Cruise, 'Some reminiscences of Belvedere College', The
Belvederian, *vol.1, no.1, 1906, pp. 21–3*

PERCY FITZGERALD

It is to the credit of the first editor of The Belvederian *in 1906 that
he invited contributions from old boys who could recall the earliest
days of the College. Percy FitzGerald recalled his schooldays in
the 1850s.*

I can look back across a long waste of years — annual milestones — to
some far off days, when I used to attend school at Belvedere House.
We carried our satchels in those times — a regular equipment, though

A. M. D. G.

" Saul hic etiam suis praemia tandi

AT THE

EXAMINATIONS

HELD IN THE

R.C. Seminary of St. Francis Xavier,

HARDWICK-ST.

On Monday and Tuesday, the 13th and 14th days of April, 1835,

Amongst a great many Candidates for literary fame the following young Gentlemen were found deserving of particular commendation.

In the FIRST CLASS.
John Harkan,
Edward Buckley,
Richard Byrne,
Joseph Mulhall.

In the SECOND CLASS.
FIRST DIVISION.
John Thompson,
Nicholas Clarke,
Joseph Dignam.

In the SECOND CLASS.
SECOND DIVISION.
James Hawkshaw,
William O'Gorman,
James Reilly.

In ARITHMETIC.
John Thompson,
William Harkan,

In the THIRD CLASS.
Samuel O'Beirne,
Thomas Higgs,
Michael Doyle,
John Joseph Donnelly

In the FOURTH CLASS.
James Carrol,
James Kelly,
Edward Nolan,
Henry Daniel.

In WRITING.
Matthew Gahan,
Thomas Higgs,
James Hawkshaw,
Edward Buckley.

James Brown,
Michael Doyle,

now, I fancy, satchels are rather out of date. We — that is, I and some friends — were about the earliest of the schoolboys; our parents were all true and faithful members of the congregation at Upper Gardiner-street, who felt it a matter of course — of high duty and pride — to send their children here. We lived in Mountjoy-square, Sherrard-street, Gardiner-street.

From an early age I had a deep reverence for and a little knowledge of architecture, and can recall my admiration for a white stately pile which stood at the top of Great George's-street, and still more

for the almost palatial chambers within — with their elaborate ceilings, chimney pieces, and panellings. They were, I recollect them, rudely partitioned off into compartments, to serve as class rooms. . . .

Hither, then, used we to repair, scampering through the streets together — not 'whistling as we went for want of thought' — but often whooping and returning in the same wild way. I can recall but one or two of my companions. Once we subscribed for a goat cart, and used to drive each other home. We were sad *gamins* — and most of us looked forward to being *gamins* in the future.

There was a quaint element of scholastic training then in vogue at Jesuit schools, and which I found later at Stonyhurst, viz., the dividing the classes into two hostile camps — yclept Romans and Carthaginians. The former had their banner, marked S.P.Q.R., and hung on a tall pole. Marks were given each day, and at the close — the victorious Roman or Carthaginian had the satisfaction of hauling down the adversary's flag. I confess the ceremonial did not excite much enthusiasm, no one — from custom staling the infinite variety — particularly cared which banner was up or down. It was in fact, as a lively judge lately said of an intellectual breakfast, 'a dismal kind of spree.' We were glad, however, of the opportunity of giving a good shout.

I said I could recall but few of my schoolfellows. Some forty years later there was a curious romantic meeting. Being High Sheriff of my county, I took my seat in the court-house in all the pride of office. I had but just succeeded to a good estate. Beside me was a well known judge, the Chief Baron, who during an interval turned to me, and said: 'Is not this a curious meeting? Do you remember when we used to run through the streets to Belvedere House — two little lads — with prospects not very encouraging. Yet here we meet to-day, you, High Sheriff — I, Chief Baron! Not so bad; eh?'

Percy FitzGerald, 'A Belvederian memory', The Belvederian, vol.1, no.1, 1906, pp. 8—10.

RICHARD CAMPBELL S.J.

In 1937 Richard Campbell S.J. recorded these impressions of his schooldays at Belvedere in the 1860s.

Once a year, on the breaking-up of the school for the summer vacation, gentlemen who had sons in the College, or who were supposed to have hopeful eligibles were invited to be present at a kind of Concertatio. Various experiments in Science were given, a scene or two out of one of Shakespeare's plays, without scenery, without any outfit, were delivered.

A list of the classes, with the names of the first four boys of each

class was distributed to the visitors and the prizes were given out. If a visitor had a son happy enough to earn a prize the Rector handed it to the father, with the request that he would present it to his hopeful.

The prizes were of two kinds: medals and books. The medal was silver, about the size of a five-shilling piece, and was awarded to him who secured the largest number of marks. He held it for the following term, and if he retained it for three terms without a break it became his personal property. I do not recollect any case in which it was permanently retained. Where are these medals now? Echo answers — Where? The book prizes were numerous. A prize was given for every subject taught in each class, even for writing, then called Penmanship. 'What's in a name?' . . .

The Elocution class was conducted under Mr Bell, one of the compilers of *Bell's Speaker*. A piece of poetry was given to be learned by heart. Next class all stood out and recited it together and then some were called out to recite it alone. Woe to him who had neglected to learn it. He did not go home until he had learned!!

Richard J. Campbell, S.J., 'Belvedere College seventy years ago',
The Belvederian, *vol.11, no.2, 1937, pp. 9–12.*

WILLIAM MARTIN MURPHY

William Martin Murphy was born in Bantry, Co. Cork in 1844. At the age of thirteen, he became a day boy at Belvedere. One of the leading entrepreneurs in the Ireland of his day he built churches, schools and bridges throughout the country, as well as tramways and railways in Britain and Africa. He was a Nationalist MP for a Dublin constituency, 1885–92 and founder and proprietor of Independent newspapers, 1905. His leadership of the Dublin employers in their opposition to the labour leader, James Larkin, in the Dublin lockout of 1913 prompted Lenin to coin the term Murphyism. He contributed this account of Belvedere in the 1860s to one of the earliest issues of The Belvederian.

I was just past thirteen years of age when I first entered Belvedere after the Easter Holidays in the year 1858.

My earliest recollection of being thrown on my own resources was when I left my home in the west of Cork, to become a pupil at Belvedere, on a bracing March morning in that year.

It was then two days' journey from Bantry to Dublin. I reached Cork the first day after a forty-mile coach drive and left about 6 a.m. next day by a train which took eight hours to get from Cork to Dublin. . . .

During my school-days at Belvedere I chummed in lodgings on the

36

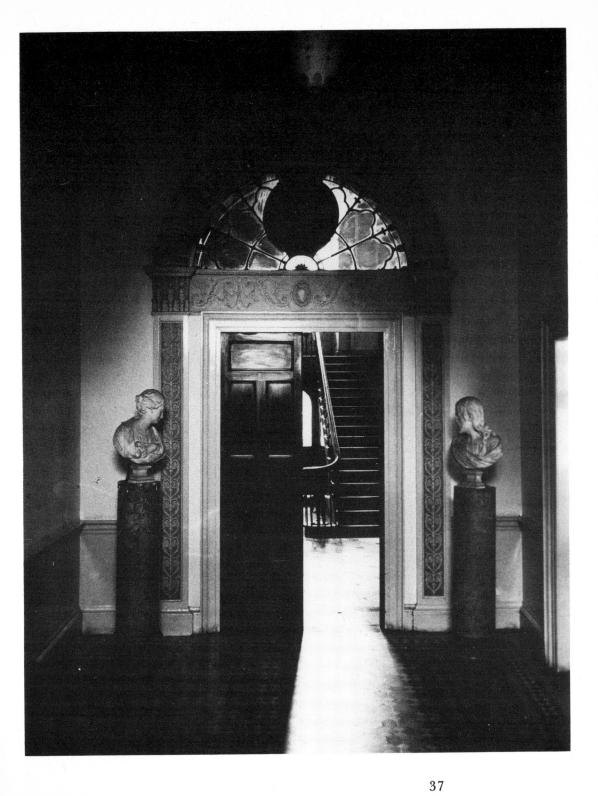

South Circular Road, opposite the old Portobello Gardens, with the late Mr Donal Sullivan, M.P., and his brother Richard, where we were provided with a free show of fireworks nightly during the summer months. It was the year after the Indian Mutiny, and the Siege of Delhi, with the blowing up of the Cashmere Gate as a *finale*, was the *pièce de résistance* at the Gardens. . . .

A boy's fitness for any particular class at Belvedere, was then, and probably is still, measured by his knowledge of Latin and Greek and I knew nothing, or next to nothing, of either, as the National School System had shortly before my time frozen out the old classical masters in the country parts of Ireland. I had, therefore, to join the junior class of the school, which fortunately for me was presided over by Father Frank [Murphy]. . . .

Another accomplishment that was taught, and well taught, at Belvedere in my time, but which I believe has been banished by the Intermediate System, was elocution and voice-production. The professor was a natty little old gentleman named Divett, who was particular that his name should be pronounced with the accent on the last syllable. He was something of a character, but was very popular with his pupils, and was certainly a very capable teacher of the art which he professed. I was always too self-conscious and diffident when I had to stand alone before an audience to benefit by his teaching. This is a feeling I never got over, and I often regretted in my Parliamentary days that I had not availed myself more of the training which the old Belvedere Elocution Master was fully capable of giving me. . . .

I recall my days at Belvedere with nothing but pleasure. I had a great deal of freedom, being very much my own master outside of school hours, but I worked hard — very hard — to hold the head of my class, which whenever I became at all slack in my studies I had to yield to a rival. . . .

I gained a knowledge of the world and a reliance on myself at an early age, which I could not have acquired at a boarding school, and I found these acquisitions of inestimable value when, being little more than eighteen years of age, I lost my father, whose only son I was, and had to take up the responsibilities of the business in which he was engaged.

I made many friendships during my school-days, outside as well as within the school. Many of these friendships proved to be lifelong, and the happy chance which led me to Belvedere was also the cause of leading me to make my permanent home some years later in the city.

William Martin Murphy, 'Reminiscences of fifty years ago', The Belvederian, vol.2, no.1, 1909, pp. 33–8.

J.A. KNOWLES

J.A. Knowles recorded these impressions of teachers at Belvedere
when he was a student in the 1870s.

The secular masters were few. . . . The writing and art master was a
Mr Moroney. He wore side-whiskers of the Dundreary type — and
was elaborately groomed. He always wore a beautiful flower in his
coat. He was a good sort and loved a little flattery. He knew his
business well and worked hard for his pupils. . . . A Mr Beatty — a
young man of fine physique but paralysed in his lower limbs — was
teacher of elocution. He used crutches and seemed to be able to
move about on them with comparative ease. He had a full-toned and
beautifully musical voice. He sat on the rostrum and showed us how
to become orators. I always had a holy dread of elocution. I bore
many a caning and confinement after school hours rather than face
the music of reciting before my schoolfellows. I remember when I
had to stand before them my attempt was received by a shower of
wads of blotting-paper steeped in ink. My effort to pose as a
Demosthenes was cut short much to my delight.

J.A. Knowles, O.S.A., 'Belvedere as I knew it', The Belvederian,
vol.8, no.1, 1927, pp. 99—101.

JOSEPH MARMION

The following extract is the only reference to Belvedere schooldays
by the biographer of Dom Columba Marmion, who as Joseph Marmion
was a student at Belvedere from 1869 to 1876.

He soon won the good opinion and affection of his masters, and for
his own part he always kept a faithful and grateful recollection of
them. The whole course of his secondary studies was marked by
brilliant success, especially in Latin and diction. With his open mind
he was naturally keenly interested in the recent discoveries made in
the domain of aerostation and electricity.

But his companions found him too much of a 'girl.' His gentleness
and sweet temper annoyed some amongst them who determined
'to make him come out of his shell' and provoked him in every way
in the attempt to force him to retaliate. Pains lost were these
attempts at 'ragging' to which those of his temperament are particul-
arly exposed. One day a school fellow struck him, having no other
reason than that just mentioned. He succeeded no better than the
others. Relating this incident to Rosie, he told her it had cost him all
his Irish blood not to hit back, but 'he had kept a strong hold on

himself, so as to imitate the good Jesus in His Passion' — certainly a noteworthy remark from a lad of thirteen.

Dom Raymund Thibaut, Abbot Columba Marmion: 1858–1923, London and Edinburgh 1932, pp. 10–11.

FROM *THE BELVEDERIAN*

In the records of those years we find the following note after the names of several of the boys: 'This boy to be carried by omnibus,' for these were the 'good old days' long before the advent of either trams or buses, and even bicycles were little more than shadows of their present selves, so the *Belvedere* omnibuses trotted round the suburbs collecting their romping fares, and delivered them safe and sound at the old mansion in Great Denmark Street.

'Twenty two', 'The days that are gone', The Belvederian, vol.9, no.3, 1932, p. 11.

EUGENE SHEEHY

Eugene Sheehy was a schoolboy at Belvedere from 1892 until 1899. This extract is from his autobiography, May it please the court, *written half a century later. Although he regrets being a schoolboy in an era when, as he claims, the Intermediate Board of Education for Ireland was pressing Irish pupils 'through the heavy rollers of its clumsy mill', he does entitle his chapter on Belvedere 'The happiest days of my life — perhaps'.*

One of the great thrills of my school life at Belvedere College was the day on which the Rector was 'kept in.'

A rather lazy boy named Lenehan was told by the Rector at Latin class to 'shut the notes and open the text', and was then questioned as to what the notes had to say with reference to some word in the text. Lenehan thought that the best way to ensure accuracy in his answer was to shut the text and open the notes. This he proceeded to do and he read the appropriate reference. The Rector must have considered it quite out of the range of possibility that the lazy Lenehan would answer correctly. In any event his comment was: 'Evidently not looked at! Remain in after three o'clock!'

This was too much for Lenehan and his reaction was spontaneous.

'Well, that's what's in the book, anyway!'

Sensation followed sensation after this outburst.

'A sulky boy will now after three o'clock write out a hundred times "I must not lose my temper".'

40

School group, *c.* 1893

'Well, it's in the book.'

'The sulky boy will now write it out two hundred times.'

'Will you, Sir, write it out if it's in the book?'

At this stage the Rector was thoroughly enjoying himself, and gave a deep chuckle.

'A very sulky boy will now write out three hundred times after three o'clock, "I must not lose my temper" and I will write it out if it's in the book.'

The material note in the text book was thereupon referred to and Lenehan was found to have answered correctly. The Reverend Rector's confusion was not mitigated by the ill-disguised merriment of the rest of the class. We all remained in after three o'clock on that afternoon, whether sentenced or not, and at about 4.15 p.m. the Rector came along with a large notebook in his hand. He had written therein three hundred times, in a beautiful copperplate hand: 'I must not lose my temper.'

When the Rector had gone we carried Lenehan on our shoulders up and down the corridor. We would, however, have liked to have chaired the Rector also because the incident did him infinite credit.

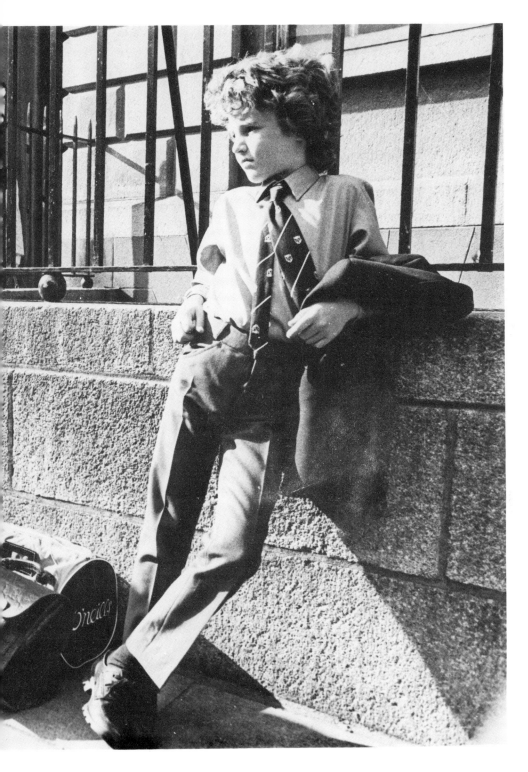

Years afterwards, after a Rugby match at Lansdowne Road, I found myself in the pavilion of the Lansdowne Football Club. At a few yards distance I recognised the figure of my old schoolmate, Lenehan. His back was turned towards me, and he was obviously keeping an important appointment with the contents of a bottle of Guinness. I stole up quietly behind him and uttered the magic words: 'Three hundred times after three, I must not lose my temper.' This startling reminder of a famous victory of thirty years gone by was too much for our hero, and a convulsive splutter resulted in a shower bath of Guinness on the floor of the Lansdowne Clubhouse.

In the book *James Joyce's Dublin*, written by Patricia Hutchins, I see that Joyce is made the hero of this conflict with the Rector. I can assure the distinguished authoress that, whoever her informant was, his memory is at fault on this point. I was present in the class during the incident, and remained in the College for the dénouement, and I can vouch for the accuracy of my account. That Joyce should now be made to usurp the place of Lenehan is an interesting example of how stories collect around the name of a celebrity when, in muddled memories, the actors in a little schoolboy comedy become confused and dim.

Eugene Sheehy, May it please the court, *Dublin 1951, pp. 5—6.*

THIS BELVEDERE

My object is merely to ask you so to conduct yourselves in the world that the name *Belvedere Boy* will, as it ought, come to be regarded throughout Ireland as synonymous with the term 'honourable, truthful, charitable and Catholic Irishman.'
'A word to the present by the president of the past', The Belvederian, *1931.*

It was with fear and trembling that we ventured last year to enter the world of letters. How timid are the little fledgelings when they first leave their nest! What a flutter fills the breast of the *debutante* on the occasion of her first 'coming out'! How anxious is the commander of the vessel on its trial trip! It was with feelings such as these, that we sent forth the first number of *The Belvederian.*
Editorial, The Belvederian, *1907.*

Jim Joyce at Belvedere

W.G. FALLON

*'Gave him one-and-a-half hours' is the note in W.G. Fallon's hand
on a letter introducing Joyce's biographer Richard Ellmann to Fallon
in 1953.[1] Fallon was one of a group of Joyce's contemporaries at
Belvedere who were important witnesses to those interested in
Joyce's schooling. In 1964, he recorded these, previously unpublished,
impressions of Joyce at Belvedere in the 1890s.*

I was in Belvedere College before Jim Joyce: we always called him
Jim Joyce. We joined up at what was then called the Junior Grade
of the old Intermediate and then we went through the Intermediate
to the end: Junior, Middle and Senior Grade. Joyce was a very
ordinary schoolboy — looked to be anyway — nothing remarkable
about him except that physically he was quite a frail boy and was
quite unequal to playing boys' games of a vigorous kind. At the same
time he would invariably be out watching games as if he had been
half ashamed of his inability to join in the games and yet wanted to
be amongst the boys playing the games: that would be Joyce about
the Junior and the Middle Grade of Intermediate when perhaps he'd
be in the neighbourhood of thirteen, fourteen, fifteen, sixteen, years
of age. Early on, Joyce was in the sodality, as most of us were, . . .
and Joyce was no time before he became head of the sodality; and he
remained head of the sodality actually until he finished with
Belvedere College, and, exteriorly at all events, he was an exceedingly
pious boy which would bring him down to eighteen years of age.[2]

We used to have boys' plays: Joyce was invariably one of the
principal characters. At that time, the Rector was Fr William Henry,
a very solemn, earnest, little Jesuit priest — with a very distinguished
record in his own student days — and he, of course, was usually at
the plays; on one occasion the chief character in the play was the
headmaster of a school and Joyce — impish fashion — imitated the
Rector of Belvedere College in all his mannerisms conducting classes.

1. Fallon, note on James J. Hickey to Fallon, 7 May 1953, W.G. Fallon papers,
 NLI, MS 22586.
2. Fallon is mistaken concerning Joyce's age: Joyce was sixteen, when, in the
 autumn of 1898, he left Belvedere and enrolled in University College,
 Dublin.

Joyce as the schoolteacher in Anstey's *Vice Versa*, probably 1898

I must say that Fr Henry enjoyed it immensely himself and complimented Joyce over it. The late Judge Eugene Sheehy — who was in the same class with me and Joyce — Judge Sheehy said, some short time before he died — we were talking about Jim: 'If Jim Joyce had only been on the films and films were to be had in those days, he'd have gone to the top in no time.' And I think he would — as a boy star. So that we do remember him as being a remarkable actor, considering his youth.

The third thing we remember about Joyce was his English essays. As we grew older through the years, we got stiffer essays to write, from a very kind old lay-master named Mr Dempsey, of the usual kind suited to our age.[3] And Joyce contributed to the essays, most of them much longer than ours. He was never in want for length; we, as a rule, like schoolboys, were glad to get to the end of the fourth page. That didn't bother Joyce in his small closely-written handwriting on foolscap paper. Mr Dempsey noticed this; drew the attention of Fr Rector to it; and the next thing that happened was that when Mr Dempsey was giving out our essays each week — indicating the title and how we'd go about it — he invariably turned to James Joyce and he said: 'And Joyce, you can write about whatever you like.' Joyce did write about whatever he liked, which had nothing whatever to do with the subject that had been assigned to us to write about. . . . One thing I remember about it was that when we brought in an essay about some subject or other, suited to our

3. For two views of George Dempsey, both by former pupils, see pp.63–7.

69 *Names etc of Boys in Belvedere during the*

Year 1893 - 94.

let's up

NAME.	BORN.	ENTRANCE.
These Names & Birth Dates are taken from the Birth Certificates.		
All boys born on or after June 1 81 can go in for Prep grade again in 1895.		
IV. Preparatory Grade -		
1.		
2.		
3.		
4.		
5.		
6.		
7.		
8.		
9. Lawless Eugene de Courcy	✓ 17 Aug 81	
10. Joyce James Augusta	✓ 2 Feb 82	
11. Wilkins Leo John	✓ 9 June 80.	
12. Hutchinson Edmund	✓ 21 Apr 81	
13. Healy Pat Jas Thomas	✓ 22 Sept 80	
14.		
15.		

age, Joyce arrived with an essay on Ibsen. Ibsen! We had never heard about Ibsen; but Joyce had pages on Ibsen. Mr Dempsey commented on this and he said: 'Joyce: I'm retaining your essay.' The upshot of that was that, by arrangement with the Rector of Belvedere College, that essay was sent to a well-known English review at the time with the statement from Mr Dempsey to the effect that it was written by a schoolboy aged about seventeen or eighteen years of age. A cheque came back to Mr Dempsey for Joyce and that I would say was the first time that Joyce found himself in the possession of money as a result of his literary efforts. . . .[4]

Excerpt, 'Belvedere College S.J., Prefect of Studies Book, 1889—1901'

4. Joyce's first published work was an essay on Ibsen in the *Fortnightly Review* of April 1900 when he was a student at UCD and had just celebrated his eighteenth birthday: it is possible that Dempsey forwarded his essay to that journal.

Casually though, as far as he was concerned, at Belvedere he always wished to be in company, just as he wished to be in company looking at football games; but he didn't stay with those he was with, he was walking ahead invariably, but comforted in the knowledge that three or four of us might be behind him. And one thing about that which I remember — must have been on a day's holiday — we found ourselves, three or four of us, with Joyce, down at Ringsend and Joyce ahead of us; we chatting about everything — not taking very much notice about what was around us — but Joyce obviously taking in everything and committing everything to memory, because years afterwards in *Ulysses* there is a paragraph describing Ringsend as it then was, wonderfully written, missing nothing, . . . and it must be that Joyce committed the whole of that to memory and yet didn't put it into writing for many years afterwards.[5] He had an extraordinarily retentive memory for that kind of thing. We weren't even aware of the fact that Joyce, twenty yards ahead of us, was taking it all in, and we, not taking the slightest notice of what was around us, chattering like schoolboys. That was Joyce at Belvedere.

W.G. Fallon's reminiscences transcribed from an interview with John Bowman, recorded June 1964.

5. In his book, *James Joyce remembered*, Joyce's contemporary at Belvedere and later at UCD, Constantine Curran, suggests that 'None of his Belvedere school-friends describes any undue, habitual aloofness in him at this time or any detachment from school routine.' Yet after his enrollment at university, Curran records a sudden change in Joyce's behaviour 'from normal companionship to an increasingly defiant, arrogant isolation. . .' which none of his friends failed to notice. C.P. Curran, *James Joyce remembered*, Oxford 1968, 107.

Did Belvedere Change, 1916-1922?

F.X. MARTIN

Was Belvedere College in the decades before 1916 a comfortable nest for young 'West Britons', or was it, on the contrary, a seed-bed for leaders who were soon to lead the nation to a new Ireland?

What really happened between 1916 and 1922 is one thing. What a nationalist historian would lead us to believe may be quite another. It is not that historians normally set out to misrepresent events — an art practised nowadays by communist and fascist governments — but even an academic historian can by selection and omission present a convincing impression which is essentially at variance with the true sequence of events and the dominant motives of those involved. It is only a generation or more later that we, with the advantage of hindsight and access to full records, can establish a more accurate picture of what took place, and why, and how. Belvedere College for the years 1916—22 is an admirable case history on this point.[1]

An historian fully conversant with the history of Belvedere during those turbulent years, 1916—22, with its Jesuit community, teachers, and pupils, would not find it difficult to identify evidence which would convince him that, at least in its pupils, Belvedere contained what Jacques Maritain called 'the prophetic shock minority', or what present-day Americans style 'the moral majority'.

The argument runs as follows. Joseph Mary Plunkett, a prominent leader of the Rising, a signatory of the Proclamation of the Irish Republic, and one of the fifteen executed after court-martial in Dublin, was a Belvederian. His brother, Jack, who was also in the GPO, and survived only to be sentenced to jail in England, was likewise a Belvederian. With them in the GPO was a nephew of The O'Rahilly, young Dick Humphreys, a university student, just a year out of Belvedere, who joined the rebel prisoners in English jails. Perhaps the bravest of the insurgents in Dublin, The O'Rahilly excepted, was Cathal Brugha, a Belvederian, second-in-command in the South Dublin Union, who sat propped up alone against a wall in a widening pool of blood from twenty-five wounds, blazing away at

1. The information for this chapter is largely based on the files of *The Belvederian* for the years 1915—24.

49

the British soldiers with his Peter the Painter, as he sang 'God save Ireland'. Eimar O'Duffy, a senior boy to Dick Humphreys in Belvedere, was in turn a senior officer to him in the Irish Volunteers, and carried in addition the distinction of recognition in those literary circles where Joseph Plunkett was an oracle. The most promising of the young Irish poets at this time was Austin Clarke, three years out from Belvedere, who made his way down to O'Connell Street early in Easter Week, to look in stunned admiration at the GPO with its garrison of Irish rebels in arms. The following year Austin Clarke and Norman Reddin placed on record, in the pages of *The Belvederian*, their appreciation of Plunkett, 'the man' and 'the poet'.

In the general election of December 1918 Cathal Brugha, recovered from his wounds but 'with the bullets still clinking inside him', was elected MP (TD) for Waterford, and became first Speaker of Dáil Eireann in January 1919. During those most turbulent years, 1916–19, Laurence O'Neill, a Belvederian, was for three successive years unanimously elected lord mayor of Dublin. Apart from the hunger-strike and death of Terence MacSwiney in Brixton Prison in October 1920 no event so roused nationalist emotion as did the execution on 1 November 1920 of Kevin Barry, who the previous year had been a schoolboy at Belvedere. When the newly constituted Irish Free State was almost brought to ruins by the Civil War the harsh heroism of Cathal Brugha's final defiance at the Hamman Hotel, Dublin, in July 1922, symbolised the uncompromising stand of the Irish republicans.

This sequence of evidence, involving prominent figures in crucial events, during the years 1916–22, suggests that Belvedere was in the vanguard of the nationalist movement. It would be a false picture. If anything the opposite was the truth. Belvedere was a school, not for gentlemen but (as in the 1930s) for 'the sons of gentlemen' (an important distinction): in a word, for the children of the middle-middle and upper-middle classes. The Plunketts, Dick Humphreys, Cathal Brugha, Eimar O'Duffy, Austin Clarke, Laurence O'Neill, and Kevin Barry, were exceptions, and, though portents of the immediate future, were not representative of their contemporary fellow schoolboys.

In this regard Belvedere was no exception among the leading Catholic colleges in Leinster. At the beginning of the century Pearse and his colleagues in the Gaelic League regarded the rising Catholic middle class as pale imitators of the Anglo-Irish squire-archy, going the way of all flesh. It was accepted that Belvedere, and Clongowes (in particular), were, if not British, certainly 'West British' (i.e. Home Rule) in sentiment. Castleknock was castigated by D.P. Moran, one of its past pupils and editor of the influential *Leader*, who renamed it 'Cawstleknock'. Over two years after the

Easter Rising an Irish journal caustically asked if the Blackrock College Union, which it declared had slavishly hastened to congratulate James McMahon on his appointment to Dublin Castle as Under Secretary for Ireland, had bothered to congratulate another past pupil, Eamon de Valera, on his election as president of Sinn Féin in 1917.[2]

The reality is that the 'true-green' nationalists, represented in their different fine shades by Eoin MacNeill, Patrick Pearse, and Tom Clarke, were in a decided minority even among Irish Catholics. This is clearly shown by comparing the numbers of those in the Irish Volunteers under MacNeill in early 1916 with those in the British forces or in alliance with them. At a maximum estimate there were 16,000 Irish Volunteers (and they were internally divided with a minority under Pearse and the majority following MacNeill). In contrast, by mid-April 1916, there were 265,000 Irishmen in the British armed forces, or in alliance with them in the RIC, the DMP, and Redmond's Irish National Volunteers.[3] For every Irishman with MacNeill there were sixteen with the British; over 80 per cent of the Irish people were actively involved in England's war effort. Yet, nowadays how few are those in the Republic of Ireland who are willing to admit that they are grandchildren of the men who were serving during 1916 in the British armed forces, in the RIC, the DMP, and the Irish National Volunteers! It is a classic example of national amnesia. If the facts cannot be controverted, then they can be forgotten. All this must be borne in mind if justice is to be done to the Belvederians of the years 1916—22.

The Belvederian of those years is an enlightening source of information on how Belvederians were thinking and acting politically amid the turmoil of national and international events — the Great War, 1914—18, the Easter Rising of 1916, the War of Independence, 1917—21, the Civil War, 1922—3. Taken in conjunction with other source material it shows in miniature, but with microscopic accuracy, the startling change which took place in Irish public opinion between 1915 and 1922.

It should be stated that there is no evidence that the Jesuit College authorities, in the persons of the successive editors, attempted to impose any political party line on the annual. The editorials, brief though they were, did cautiously echo certain sentiments, but the main impression of what Belvederians were thinking and doing comes from the record of their activities during those years. Of course, an

2. See F.X. Martin, '1916 — Revolution or evolution', in *Leaders and Men of the Easter Rising: Dublin 1916*, ed. F.X. Martin, London and Ithaca (USA) 1967, 239—52, at 249.

3. See the figures, based on official records, given by F.X. Martin, 'Eoin MacNeill on the 1916 Rising', in *Irish Historical Studies*, 12, (1960—61) 226—71, at 243 n.15, 244—5 n.20.

Belvedere and the War.

Roll of Honour.

CAPTAIN HUGH O'BRIEN.

CAPTAIN PAGET O'BRIEN BUTLER.

LIEUTENANT FRANCIS LYNCH.

LIEUTENANT JAMES McLOUGHLIN.

2ND LIEUTENANT G. PLUNKETT.

SURGEON RAYMOND O'C. REDMOND, R.N.

EDMUND BURKE.

RAMSAY HALL.

R.I.P.

Belvederians Serving in the Forces.

The following list is known to be far from complete. Any additional information relative to O.B.'s in the Army or Navy will be thankfully received by the Editor of THE BELVEDERIAN.

NAME.	RANK.	REGIMENT.
Breen, Ian		At Sandhurst.
Burke, Austin		
Burke, Edmund		Irish Guards (**Killed**).
Burke, Francis	*Surgeon*	.. R.N.
Burke, Francis	*Captain*	.. 5th Connaught Rangers.
Burke, George	*Sergeant*	.. Irish Guards (**Wounded**).
Burke, John	*Lance-Corporal*	.. S. I. Horse (**Mentioned in despatches**).
Burke, John	*Lieutenant*	.. R.A.M.C.
Burke, Mark.		
Byrne, John	*Captain*	.. R.G.A. (**Mentioned in despatches**).
Byrne, Leo	*Lieutenant*	.. Canadian Rifles.
Callaghan, Stanislaus	*Lieutenant*	.. R. Flying Corps.
Campbell, Charles	*Lieutenant*	.. R.A.M.C.
Carroll, Joseph	*Captain*	.. 6th Royal Dublin Fusiliers.

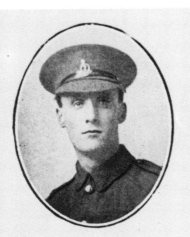
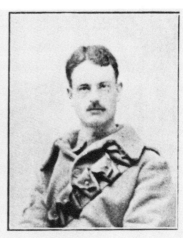

CAPT. F. BREEN,
R.A.M.C.

LIEUT. J. BURKE,
R.A.M.C.

LCE.-CORP. J. BURKE,
S. I. Horse.

editor could create a particular impression by inclusion or exclusion
of selected information, and this did happen (probably unintention-
ally) as we shall see in the case of Laurence O'Neill, lord mayor of
Dublin, but there was no political or cultural policy imposed by the
College authorities. The annual reflects the views, to a limited extent
of the pupils, but in the greater measure of the recent school-leavers
and of their parents.

The Belvederian of 1915 has much on the Great War. The editorial
does not beat any war drum, but there are articles on safe war topics:
French Jesuits in the war; the experiences of Dom Columba Marmion,
the (Old Belvederian) Benedictine abbot of Maredsous in Belgium;
the Knights Hospitallers in medieval times. Some attention is given to
the National Volunteers, led by John Redmond, with an article and
photographs of men drilling in Belvedere Park. There is news about
two Old Belvederians, Vincent O'Halloran and A.B. Culhane, pro-
minent officers in the force, but no mention of the Irish Volunteers
led by MacNeill.

The impact of the war on past pupils of the College is apparent
in the feature 'Belvedere and the War'. It begins with the 'Roll of
Honour' — six officers (army and navy) and two privates, killed.
Then comes the impressive list of 121 men, almost all officers,
serving with the forces, and four military chaplains who had taught
at Belvedere. A substantial number of the old boys were with the
Royal Army Medical Corps, but the fighting men were in all branches
of the forces — army, navy and flying corps. They were not con-
centrated in particular regiments, and freely joined English, Welsh,
South African, and Indian brigades. Many had become students or
graduates of Trinity College, Dublin, and more than one member

53

In Memory of Belvederians who have fallen in the Great War. R.I.P.

Frontispiece, *The Belvederian*, 1916

of a family joined — there were four Coppingers, three Ryan brothers and three Freemans. The school diary, 'Belvederian Milestones', compiled by schoolboys, shows the pupils enthusiastic for Redmond's National Volunteers, for the viceroy, and for Asquith, the British prime minister.

The Belvederian which appeared in 1916 could not overlook the Easter Rising, but the Great War was still the main political issue. The volume was dedicated to those who had fallen in the war, and

54

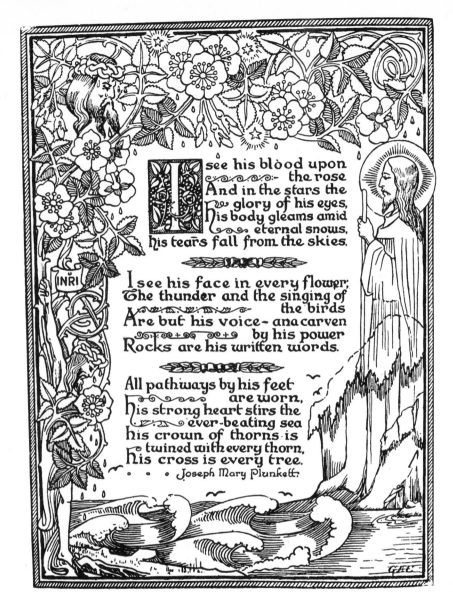

I see his blood upon the rose
And in the stars the glory of his eyes,
His body gleams amid eternal snows,
his tears fall from the skies.

I see his face in every flower;
The thunder and the singing of the birds
Are but his voice—and carven by his power
Rocks are his written words.

All pathways by his feet are worn,
His strong heart stirs the ever-beating sea
his crown of thorns is twined with every thorn,
His cross is every tree.

— Joseph Mary Plunkett.

Frontispiece, *The Belvederian*, 1917

the editorial stated that 'Our past pupils in hundreds are taking their part in the great struggle, and to them we give our first attention in the present number, feeling as we do, that in them the interest of all Belvederians centres'.

Former pupils of the College travelled from all parts of the globe, from South Africa, South America, New Zealand, Australia and Siam, to join the fight. The list of casualties and dead increased sharply and quite a few were awarded decorations for bravery. There

A Rebel's Diary

BEING EXTRACTS FROM THE NOTES OF AN OLD BELVEDERIAN WHO FOUGHT IN THE REBELLION OF EASTER WEEK, 1916.

Scene and Time—BAGGOT ST. BRIDGE, EASTER MONDAY, 1916, 12.50 P.M.

Suddenly through the heavy dust-laden air of that fatal bank holiday two shots ring out reverberatingly. Then follows a machine-gun-like succession of reports, bang! bang! bang! People stop on the footpaths and look questioningly at one another. A very few straightway realise what has happened, and become the centres of chattering crowds. All at once one notices that a great silence, terrible in its unnaturalness, has fallen on the city. Then again come those foreboding shots, seven or eight whipping out viciously the imperial summons of the god Mars. Two policemen run up from the Stephen's Green direction and scurry into Lad Lane. Some queer feeling in the air prevents one from wholly realising the utter ridiculousness of their action. At the moment one seems capable of unmovably watching the most grotesque thing. A valiant sergeant suddenly makes his appearance from nowhere in particular, and proceeds to stop all outward-bound cars. One motor driver remonstrates indignantly, disdainfully daring anyone to attempt to stop him. Later on his car was seen picturesquely placed at one end of the Shelbourne barricade.

At Stephen's Green (East) a large and ever-increasing crowd has collected. Rumours of Hun-like atrocities abound on all sides. Nevertheless the self-same crowd seems to have a strange confidence in these " Huns," considering that barely the width of a street separates them. Save for the complete absence of holiday-makers, and the barred gates, indeed, one would notice nothing unusual on glancing inside the Park.

* * *

The afternoon passes slowly. Crowds throng around the different positions. Everyone is waiting for the supposed coming advance of the military. Then suddenly rumour has it that Germans have been seen on the North side. One old lady informs me gratuitously in Westmoreland Street that a " corpse of Germans " has landed in the Park, whether from warships or Zeppelins not stated. Likewise she adds that the Sinn Feiners have set up a courthouse in the

were now six military chaplains who had taught at Belvedere, and two of them, Fr John Gwynn and the saintly Fr Willie Doyle, were to die in the battleline.

The overall sentiment of *The Belvederian* was still one of admiration for the heroes in British uniform. However, a totally new factor, the Easter Rising, could not pass without comment. It does the editor of *The Belvederian* credit that an article 'The April Rebellion' was included. The writer diplomatically stated that it was 'a question about which widely divergent views will be held by our readers'.

56

He was also responsible for an Irish bull which would have been amusing but for the tragedy involved; he said of the rebellion — with the obvious intent of being detached — that it was 'a fratricidal struggle in which many of our past pupils fought on both sides'. Belvedere itself was in the fighting area but suffered only a broken window, though it was also described as 'peppered with bullets'. By a coincidence the British troops in front of the College were under the command of a Belvederian, Captain Eugene Sheehy of the Dublin Fusiliers.

Two former pupils lost their lives — Joseph Plunkett, who was executed, and on the British side, Corporal Reg Cleary who was shot dead near Beggar's Bush barracks. He was one of the auxiliary volunteer troops entitled 'Georgius Rex', irreverently known in Dublin as the 'Gorgeous Wrecks'. Several other Belvederians were involved in action against the rebels. Lieutenant Gerard was wounded near Beggar's Bush barracks; Lieutenant L. Hilliard captured one of the rebels flags at Marrowbone Lane Distillery; two other Belvederians with the forces, and back from France, Geoffrey McCullough and Rory Roche, joined in action against the rebels, as did Lieutenant J. Little.

To further confuse the emotions about Easter Week information now appeared in *The Belvederian* about former pupils who had fallen the previous year, fighting with the British forces on far foreign fields. Three of them — Lieutenant William McGarry, Lieutenant Kevin O'Duffy, and Captain J.V. Dunn — had been killed within one week of August 1915 on the bloody beaches of Suvla Bay, Gallipoli. Two months earlier, also in the Dardanelles, Lieutenant Gerald Plunkett, had been killed. He was aged twenty-seven, a graduate of Oxford, and had been a practising barrister in Ireland. The enlightening snippet of information is added that he was the only Catholic on the Rathmines Town Council.

The sign of the change to come was mirrored in the notes by the schoolboys, in 'Belvederian Milestones', when they commented 'however tragic the events of Easter week, there is a gleam of glory shining through the tragedy as it shows through all Ireland's tragedies. Whatever may be our own views and ideals, as Irishmen we must be proud of the pluck and chivalrous heroism shown by our rebel fellow-countrymen during the tragic rising of Easter 1916'. That indication of rebel sentiment stirring among the schoolboys was given strong voice by two young men, Austin Clarke and Norman Reddin, who had left Belvedere a few years before. In *The Belvederian* of 1917 they published two articles in praise of Plunkett, the executed leader. Though the editorial in that issue began with the statement that 'our magazine is non-political', there was a manifestation of pride in what had taken place in Easter Week. The frontispiece of the volume has an engraved page of Celtic design framing Plunkett's

poem 'I see his blood upon the rose'. The blood-sacrifice notion was working even among conservative Belvederians, and the terrible beauty was being born. This issue of the annual also contained an article, 'A Rebel's Diary', by Dick Humphreys who had fought in the GPO and served his time subsequently in English prisons. The annual took note of the fact that Sir Roger Casement was defended in court by Serjeant A.M. Sullivan, a Belvederian.

Yet no matter what change was taking place among the schoolboys and those who had recently left the College, the roll-call of those serving with the British forces continued to occupy a large place and to demonstrate the political loyalties of the older generation. There was mention of the fact that 'the Flying Corps has attracted many Belvederians' with not a few gaining military decorations.

The political change continued to work particularly among the schoolboys, as can be seen in the motions discussed by the Debating Society. They concerned questions of a republic and of colonial rule in Ireland: an entry in 'Belvederian Milestones', for 18 April, noted that 'the sinister rumours of conscription are finding a steady echo behind our hallowed walls'. There was an increased interest in hurling (which had always found supporters in Belvedere) and in the Irish language.

It is perhaps in *The Belvederian* of 1919 that the changed attitude in editorial outlook becomes clearer. A full page is given to congratulating Laurence O'Neill, who for the third time was unanimously elected lord mayor of Dublin. It is significant that this was the first time *The Belvederian* adverted to the fact that he was a past pupil of the College. For the first time also there was mention of Cathal Brugha, and tribute is paid to his success as a businessman and to his prominence in the Rising and in subsequent political affairs. The annual records that Stephen O'Connell, who left Belvedere in 1918, had been sentenced to six months in Mountjoy Jail for drilling in Clonliffe Road, but that he and twenty other prisoners made a daring escape from the prison in broad daylight. While rightly continuing to give adequate mention to Belvederians still serving with the British forces in France and elsewhere, *The Belvederian* for 1920 records that Dick Humphreys was one of those engaged in the 'memorable hunger-strike in Mountjoy' in 1919.

The political crisis in the country is evident in the 1921 issue. The most notable event recorded was the capture and execution of Kevin Barry. The contribution by the schoolboys in 'Belvederian Milestones' has a succession of sad events to record:

29 Oct. 1920—'No school today. We are in mourning for the great lord mayor of Cork [Terence McSwiney] whose spirit the greatest of the Empires could not enslave'

Kevin Barry

1 Nov. 1920—'yet another day without school! Our pleasure in the free day is gone. Kevin Barry our school-fellow scarcely a year ago, proving himself a patriot meets a criminal's end at the hands of the freer of small nations'

18 Feb. 1921—'There's some use in the British army after all. Mountjoy area being invested, we get off early'

14 Mar. 1921—'Not for the first time this year do we get a free day that we would rather not have. Six Irishmen being hanged this morning in Mountjoy. The school does not open today'.

The Belvederian of 1921 contains an eye-witness account, 'Under fire at the Custom House' by 'P.Ó.C.' who, for good reason, wished to conceal his identity. This was Patrick Kennedy, at Belvedere during 1905—11, who became a British civil servant, was transferred to London in 1914, where he was associated with Michael Collins and other expatriates in Irish cultural activities. He was transferred back to Dublin in 1919, where he was one of Collins's 'spies in the

Castle'. Another transfer took him to the Custom House, and he was there in May 1921 when the Irish Republican Army seized and burned the building. Hence his article in *The Belvederian*. He rose to the top rank of the Irish civil service, and died in 1980.

It hardly comes as a surprise to find *The Belvederian* of 1922 carrying a trilogy of articles bearing the general title, 'Under the Terror'; the first by Kenneth Reddin, 'In a Sinn Féin Court'; the second by Michael O'Brien, 'In Ballykinlar [internment] camp'; the third by Fergus Murphy, 'In an English Prison'. Even a review of a new edition of Weston Joyce's *Neighbourhood of Dublin* apologises for a book dealing with the Pale, 'where almost every record tells of the invader'. The political change showed itself in the 1923 annual in the fact that a significant number of former pupils of Belvedere College had become officers in the Irish Free State army. The different political and cultural strands in the Belvedere tradition are chronicled in *The Belvederian* for these years: Cathal Brugha died defiantly, the symbol of Irish republicanism, in July 1922; earlier in March, Major T.J. Crean, a Belvederian in a very different tradition, died. As a young fellow of eighteen he was awarded a medal for life-saving in the sea. He became a rugby international, qualified as a doctor, and gained the Victoria Cross in South Africa, to which he added the DSO during the Great War. His record was the kind one would expect from a model for a British public school. In 1923 another Belvederian, James MacNeill, was appointed first Irish Free State High Commissioner in London, representing the new state at the Court of St James.

Undoubtedly a political revolution had taken place in the country which affected the outlook of the pupils at Belvedere College, but there was no violent change in their social pattern. Belvedere had catered for the middle class at the beginning of the century and this was still the case throughout the 1930s when I was a pupil there. The atmosphere favouring the upper, rather than the lower, middle class was brilliantly parodied by another Belvederian, the talented Jimmy O'Dea, the idol of music hall fans in Dublin. I remember the hilarity and thunderous applause of the audience in the Gaiety Theatre as he sang, with exquisite mimicry of a West British accent, the refrain, 'Thank heavens I live in Rathgar'. The distinction within the middle class was lampooned in the lines:

'In Terenure they play tennis in braces,
Thank heavens I live in Rathgar!'

It required a full generation and more, before the effect of the new Ireland showed itself a major feature among the parents, as it already had among the boys, of Belvedere College.

62

George Dempsey

Without doubt George Dempsey was Belvedere's most celebrated teacher: his role as James Joyce's English teacher alone would have ensured this. He was on the College staff from the era of Parnell to that of W.T. Cosgrave. Joyce's biographer, Richard Ellmann, gives this portrait of Dempsey: 'He dressed unusually well, wore a moustache, and carried a flower in his buttonhole. His diction and manner were old-fashioned; . . . His pupils irreverently called him 'D'ye see' from his favourite expression. . . .'[1]

On the occasion of his Silver Jubilee in 1910, one of his former pupils, William Dawson, wrote this account of Dempsey the teacher as he remembered him 'when the 'nineties were still young'.

The scene most strongly imprinted on my memory is the Middle Grade class, then entrenched in No. 2. Here, for an hour three days a week, we sat at Mr Dempsey's feet. The class was usually held between 1 and 2 p.m., an excellent period, coming, as it did, after the pangs of hunger had been appeased, and before the feverish unrest, which the end of the day always produces, had commenced to make itself felt. Mr Dempsey seated himself on a chair before the front desk — he disdained the giddy eminence of the throne — and after a jovial, perhaps slightly sarcastic greeting to his pupils, proceeded to sound the depths of their ignorance. It was part of the settled procedure that each text-book was brought by a separate youth listened delightedly to encomiums for his master. Altogether turn to the Professor. It was a glorious position. We felt like Cabinet Ministers. The fortunes of the class were in our hands. Hoarse whispers or scraps of paper frequently reached us from 'the backwoodsmen' praying that the history might be put on next, or entreating that the geography might be delayed. Then there were exhibitioners in our Cabinet, and it was felt that a timely word from them might serve to avert a crisis in the class.

Wednesdays were days of joy and sorrow mingled, for on these days essays were often read aloud by Mr Dempsey. The essays were the result of original efforts by the boys on the previous Sunday, and too often proved mere mirth-provokers for their colleagues. Sometimes an essay was deemed worthy of praise, and a blushing youth listened delightedly to ecomiums from his master. Altogether it was a delightful oasis in the arid day, combining instruction with

1. Richard Ellmann, *James Joyce*, Oxford 1959, p. 36.

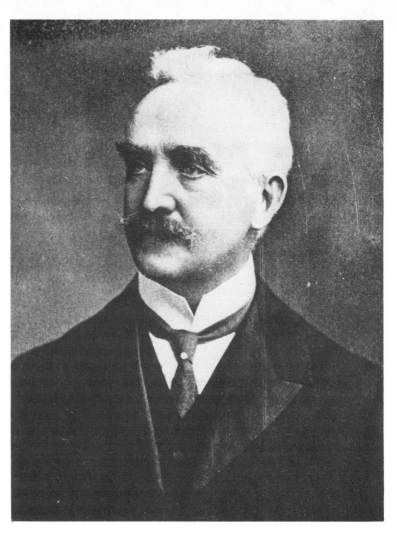

George Dempsey

amusement, learning with laughter, work with rest. That, at least, is my recollection of the English hour under the sway of Mr Dempsey.

As it seems to me now, looking backward down the years, Mr Dempsey's method was more like that of a University professor than an Intermediate teacher. He had a friendly bearing towards his class, he drew out the good points of his pupils, he enhanced what was interesting, he enlivened what was dull. Though his temper was rarely ruffled, his class was never unruly. The discipline was perfect, but the yoke was not galling. Now and again the lazy were compelled to feel the leather, and no one who attempted a liberty ever tried to do so a second time. Few, indeed, were so minded. What severity often fails to secure was freely accorded to kindliness. The Jubilee celebrations, described elsewhere, show how the memory of these days has been an abiding one.

64

Outside class it was the same. No boy feared Mr Dempsey. If he was espied on his way to or from Belvedere none of his pupils lagged behind with a view to dodging him. He interested himself in their pursuits, advised them what books to read; even counselled them what plays at the theatre they should go to see. Nor was it necessary to be of his class to be of his friendship. The best known figure among the lay-masters (as we styled them), he made himself acquainted with the youngest in the school. As it was then, so I am sure it is now. What was true of Mr Dempsey in the close of the nineteenth century is, without doubt, equally applicable to him in the beginning of the twentieth.

William Dawson, 'Mr Dempsey: an appreciation', The Belvederian, vol.2, no.2, 1910, pp. 180–82.

On Mr Dempsey's retirement in 1924, Arthur Cox, another of his former pupils, paid him this tribute in The Belvederian.

Nearly forty years ago Mr George Dempsey came as a teacher to Belvedere, and his retirement now, after so long a period of honourable and exacting toil, marks a date in the history of the College. It has known many great professors, and especially many famous teaching members of the Society which founded and conducts it, but none greater than he. The present year is in many ways an epoch for Belvedere, to which the new era opens a great expansion in the number of her pupils and the scope of her activities; but for countless Belvederians it is marked most of all by this loss rather than by its many gains. The teacher is less known to those not in actual contact with him than is the lawyer, the doctor, the soldier, the politician; but to his own pupils the teacher remains through life the most enduring memory and influence of all.

The wide province committed to Mr Dempsey's care in the division of College studies included English, literature, and history, and gave to him the most important scope of any teacher save those concerned with Divine things. And so his influence through so many years in the greatest of Dublin's schools has been and is enormous and far-reaching upon the vast numbers of students who passed through his care. Boys whom he had taught lived to be prominent figures in every walk and profession, and came to lead in the very diverse movements of modern Irish politics and life. The Irish Party, the Sinn Fein movement, and much else that differed otherwise, were alike in this that they included many who derived much from him. Not a few of those who first learnt from him of olden wars, of nationality, of patriotism, came in the great upheavals of modern times to die for ideals which he had taught; some far away in France or Gallipoli, and others here at home in the streets of

Dublin or upon the hillsides of their own land. So many men in so many different spheres and movements look back to him as one of the chief fountains of their thought and character. In his retirement and declining years he has this great consolation and pride that in all these many men much of the good and nothing of the bad was and is attributable to him. Like Goldsmith, who touched nothing that he did not adorn, George Dempsey came in contact with no boy whom in a nobler way he did not adorn in thought and in endeavour.

What was the secret of Mr Dempsey's success? It would be hard to define it, for his success sprang from qualities easier to define than to describe. Only a Charles Lamb would, I think, be competent to the task. His genial smile and kindly manner invited friendship from even the most reluctant and unwilling student; his strong character and firm will compelled respect; while his keen mind and lively interest in the wide range of subjects entrusted to his teaching awoke also in the dullest both interest and appreciation. Year after year examination results testified to his professional capacity; no less frequently his past pupils showed in some better way their affection and esteem. History, and particularly Irish history, he made a thing of life and actuality; literature ceased to be a question of books and broadened out to meet the confines of thought and experience; geography

66

became converted from a dull affair of names and lists into what it really is, the science of all peoples and of the world. He was a great educator, and approached more nearly to the best ideal of the University professor than the mere school teacher; yet he surpassed the professor in this, that above all he taught character.

Boys in every grade and class felt his charm and influence in an equal degree. The beginner was as much an object of his care as the advanced student. There is probably a wider chasm between the mind of the boy of ten and that of the boy of sixteen or seventeen than between the man of thirty and of sixty; but he understood every age and could with unerring finger touch every chord of all his students.

One hears much, and deservedly so, of the influence upon a nation of a great thinker, but that of the great teacher is infinitely wider and deeper. It is sad to reflect that the work of such a man as Mr Dempsey has reached its finis, but its effect does not end, outliving him, and perhaps outliving and passing forward to future generations from those whom he had taught. The classrooms of Belvedere know Mr Dempsey no more. The familiar figure, upright and erect, is seen there no longer: after forty years the school bell is answered no more by him; the well remembered voice is no longer heard; but what has been accomplished is not lost and may bear fruit hereafter.

Some fourteen years ago it was permitted to some of his past pupils to testify to Mr Dempsey upon the occasion of his silver jubilee at Belvedere their gratitude and appreciation. At that pleasant function some now gone and many who remain gave testimony to what they owed to him and joined in wishing to him many further years of active work and of happiness. It is at least a consolation to know that if the labours have ceased many future years of happiness must still after this further lapse of time remain to him; and to the writer a pleasure to reflect that this little appreciation is no epitaph, but merely another essay which he remains to criticize — it is to be hoped with the same kindliness but with less severity than many an essay of what now begins to seem 'the long ago'. If Mr Dempsey can no longer be the teacher of young Belvederians he still remains with us as the same kindly friend, the same wise counsellor, and the same generous helper, of those who once were his pupils and still remain his debtors.

Arthur Cox, 'George Dempsey', The Belvederian, Vol. 7, No. 1, 1924, pp. 78–80.

Recollections, 1917-1925

MERVYN WALL

At the recent funeral of an old schoolfellow a man older than myself introduced himself to me, saying that he remembered me at school and that he was now seventy-five. I remembered him, and we spoke of our schooldays, as inevitably happens when after long years elderly people meet who have common childhood memories. 'There was a great deal of sadism', he said and mentioned a Jesuit whom I recalled as having had a permanent sneer on his face and as seemingly all the time engaged in a search for a reason, however slight, to order or administer physical punishment. To be truthful, if I were asked to say what I most vividly remembered of my schooldays, I should have to answer: 'Fear', at least during my four years in the Junior House, which in my case was from the ages of eight to eleven, but I believe that I would give that answer with a wry smile, and though wry, it would nevertheless be a smile. In other words I do not bear any resentment, and I think that very few of my one-time school companions do so either. I and they would simply state the facts. If anyone were to say to me: 'You are ungenerous to recall the unpleasantness of schooldays', I would answer in St Jerome's words: 'If an offence comes out of the truth, better is it that the offence come than that the truth be concealed.

Children are fatalistic, accepting as inevitable all that happens to them. The aged man who spoke to me was not correct in saying that there was a great deal of sadism. It may have lurked in the character of that one cleric whom he mentioned, but we all know the saying about the presence of one rotten apple in every barrel. The truth is that discipline in Belvedere was severe. Not to know your lessons was seemingly regarded as moral turpitude. We had of course been warned by elder brothers and by elder boys when we were due to enter school, that certain teachers were 'devils' and that others were 'decent'. In the outcome we liked some despite their frequent wielding of the strap, we disliked others but it would have been largely because of their manner and approach, and many we just accepted. School and its disciplines and punishments were just of the nature of things, and we could do nothing about it.

The mother of a schoolfellow of mine once called to see the Rector, Fr Fahy, to plead with him not to allow her child to be subjected to so much 'biffing', as we called it. The Rector's reply

was that boys have such a bad time in later life that it is necessary
to harden them. Bulmer Hobson, one-time North of Ireland Quaker
and subsequently Irish revolutionary, once remarked to me: 'The
only important thing about children is to have them happy.' I lean
towards his attitude rather than towards that of the Rector,
believing it to be the more Christlike. Were not the disciples instruct-
ed by St Paul, and are not present-day seminarians similarly instruct-
ed, to be *alteri Christi* — other Christs?

I think it likely that our teachers in Belvedere copied the dis-
ciplines of English public schools. An English literary journal recently
commented on the fact that during the past forty years there have
been in countless published autobiographies terrifying accounts of
the severities and punishments practised in the public schools of
Britain. Widespread physical punishment seems to have been the
universal practice in these islands, and educationalists never seem
to have adverted to the fact that they were hammering into the
young the lesson that desired results are best achieved by violence.
I am told that nowadays methods have entirely changed and that in
Irish secondary schools physical punishment is no longer administered

for failure at lessons, but only for acts of indiscipline. Stephen Dedalus, thinking of his schooldays, admits that only once was he subjected to physical punishment, but Joyce's school companion Judge Eugene Sheehy has written of the author that he was always 'a goodie'. In my time I am afraid very few of us were 'goodies', but even the few whom I remember I had often seen hugging their hands beneath their armpits or blowing on them to sooth their aching palms.

My own experiences were quite bad. I was first introduced to the strap in Fourth Grammar at the age of eight. A teacher of English, Dan O'Carroll, who had been a Volunteer during the 1916 Rising, and whom we disliked because of his cold severity, had set us the usual four lines to be known by heart in the poetry lesson. I got as far as reciting

> I am monarch of all I survey,
> My right there is none to dispute.
> From the centre —

and there I stuck. 'Wall, get six', he said and wrote out the little note for the executioner, Fr Campbell, who operated on the landing at eleven and at a quarter-to-two every day in full sight of the boys streaming up the stairs to class, so that justice might be seen by all to be done.

It interested me in later years to read in *A Portrait of the Artist* mention of the same Fr Campbell whom Joyce says the boys called Foxy Campbell or Lantern Jaws. In my time he was a formidable old man in his seventies with a bowed back who used to work himself into such a state of indignation at the wickedness of the young, that he would spray the front desk with saliva, and on one glorious occasion even spat out his false teeth, not that a single child in his class dared to smile. I prefer to use the word 'child' of the pupils in the Junior House, that is, those up to twelve years of age. I would like teachers to use it too, to remind themselves of the extreme unsophistication of those whom they rule. The universal use of the term 'the boys' seems to me to have a somewhat pejorative quality, implying a sort of Boys' Brigade of assorted individuals who are to be drilled as one so that they may all act alike.

I suffered much under Fr Campbell, and my classmates did too. He took us for Latin in Third Grammar when I was nine, and he had an iron rule. He examined one half of the class on their Latin vocabulary on alternate days, and failure to answer to his satisfaction meant 'six of the best' administered on the spot with the strap which he carried in the pocket of his soutane as did all the clerics who taught the Junior House. Lay teachers had not the authority to administer physical punishment. They wrote a note for Fr Campbell, and it was their victims who waited twice a day on the

landing in silent and apprehensive queues. I was biffed every second day without fail by Fr Campbell, and on the other days of the week as often as not by other teachers. I never failed to do my written exercises, three a night, but it was in memory work that I failed. I now know that having to memorise Latin, French, Irish, History, Geography, English Grammar, Arithmetic and Religious Knowledge was too much for a boy of nine, but children have not the power of explanation and must take all that comes. In the month of May, one month before term's end, my parents, shocked at my appearance and fearing a breakdown, removed me from school and sent me for three months to the country.

I scored one secret triumph that year. I persuaded a classmate on the last day of the autumn term to join me in stealing the strap which Fr 'Cherry Blossom' Byrne, a popular teacher who told us stories in class occasionally, had unwisely left in his desk. At the top of North Great George's Street we gleefully sawed it in two with a penknife. This daring feat had to remain a secret, because the consequences of its discovery would have been too awful to contemplate.

Fr Byrne, nicknamed 'Cherry Blossom' because of his florid face, a likeable humorist called Fr Dillon and the much-liked Fr Charlie Moloney wielded their straps whenever they thought the occasion called for it, but I do not think that they liked having to do so. They were impelled by what they thought to be their duty. I read recently Cardinal Newman's stricture that the Jesuits always do the worst things from the best of motives, and who am I to contradict a great and wise churchman? I described in my last novel, *Hermitage*, Fr Molony's rule in the year during which he taught us French in Second Grammar when I was ten. He set us ten sentences to translate into French for our three-times-a-week French exercise. Any child who made ten mistakes was to get six slaps from the strap administered by him on the spot. I remember to the present day the mounting terror and the growing hush that fell on to the class as, when I had copied out my ten sentences with chalk on the blackboard, he ever so slowly corrected my sentences, and the number of errors crept slowly upwards and finally totalled ten.

Of course twenty to thirty small children in a class must often exasperate a teacher because of their seeming inability to take in what they are being taught, and when they have taken it in, to recall it on demand. Gosling, the porter of Greyfriars of which we read avidly in the boys' magazine, *The Magnet*, had a favourite saying: 'Small boys should be drowned at birth', and many teachers would probably agree that he had a point. We had our escape into a world of the imagination in reading those children's magazines, *The Magnet*, *The Gem*, *The Boys' Friend*, *The Union Jack* and the Sexton Blake and Nelson Lee booklets. In my first year at Belvedere the door of our classroom, Fourth Grammar, was one day suddenly flung open,

and as if by magic the Rector, Fr Fahy, was in our midst. None of us eight- and nine-year-olds dared to breathe. The young cleric who was conducting the class, stood back behind his desk, loosely at attention. With a dramatic gesture the Rector plunged his hand into the pocket of his soutane, and pulling out a familiar green publication, held it aloft. 'The Boys' Friend', he announced in ringing tones. 'No, the Boys' Enemy!' No one dared to stir, because I am sure that in every hip pocket there was, as there was in mine, a copy of that or of a similar publication.

Years later I asked an old schoolfellow, Fr Paddy Crean, who became Head Chaplain of the Irish Army, and twice did service in the Congo, why our teachers had been so condemnatory of those boys' papers which were harmless, which played a great part in teaching us the pleasure of reading and which had been so highly praised by G.K. Chesterton. He smiled and said: 'I think they suspected heresy.' I do not think so. I think that the school authorities considered that it was their pupils' duty to give all their attention to study, that extraneous reading matter might detract from the performance of that duty, and that recreation should take the form of rugby football or other games. I never played games at school. I lived in Palmerston Road, and to have travelled across town to Jones's Road to practise was quite out of the question. I turned up of course at Lansdowne Road to watch the semi-finals and finals of the Junior and Senior Schools Cups, and like the others cheered myself hoarse for Belvedere.

In First Grammar we were introduced to Euclid and Algebra by the terrifying Fr 'Skull' McLoughlin, a walking skeleton with a bald head, who had an alarming habit when entering the classroom of taking his strap from his pocket, fondling it and waggling it up and down, and all the while emitting chuckles such as you might reasonably expect to hear coming up out of the depths of hell. We understood that he had been a British Army chaplain, and he occasionally told us stories of young men coaxed to join the IRA, handed a revolver and told to shoot some inoffensive policeman. That was late in 1919, but things were changing, and in the following year a young Jesuit who taught us Irish History was urging on us in class our duty to our country. He distributed stencilled copies of Thomas Ashe's 'Let Me Carry Your Cross For Ireland, Lord' for learning by heart.

We were of course aware of the larger events happening outside the walls of our homes and of school. I travelled daily by tram through the ruins of O'Connell Street. We were once sent home early to avoid being trapped behind a military cordon which was slowly moving down Great Denmark Street searching every house, and on the same day a couple of us witnessed a young cleric discussing with Mr Boylan who taught science and was known to us for his patriotic utterances, how best he might escape the cordon through a window

74

and over the roofs. On the morning of Kevin Barry's execution there was a Mass for him in the College Chapel. Leaving school one day we heard that the Custom House was on fire, and I and a companion hurried to see the spectacle until we were stopped in Marlborough Street by a woman in a shawl. 'Don't go down there, son. There's shootin'.' We were frequently passed in the streets by lorries full of British troops, their rifles protruding over the sides of the vehicles. In 1918 I had witnessed a boy in the playground, who had admitted to being a Sinn Féiner, being set upon and abused by his classmates. No doubt the children echoed their parents' views, but eighteen months later all had changed, and our loyalties were in no doubt. All at once we ceased to buy and read *The Magnet* and *The Gem* and other British magazines, believing that it was unpatriotic to do so.

Once we graduated into the Senior House to First Preparatory, the incidence of physical punishment fell off greatly. Perhaps we had learnt the discipline of study, perhaps our memories had improved, or perhaps we had merely become more adept at avoiding trouble. As I was deemed to be too young at thirteen to be advanced to Junior Grade, I was kept for a second year in First Preparatory, and that was a year of which I have happy memories. Fr Frank Browne, a likeable teddy bear of a man, organised visits after school to the Central Fire Station and Maguire and Paterson's match factory. Doing the same course for a second year made lessons easier for me, and Fr Browne was a good storyteller as well as a good teacher. I owe him the ease which I soon gained in Junior Mathematics and Science. Most of the punishment which I earned in those first two Senior House years was in the form of a half-an-hour's detention after school, and the reason was almost always the same: my arrival five minutes late in the mornings. I do not know why I was so frequently that five minutes late. My brothers and I never saw our parents until the late evening at dinner. The business of rousing us in the morning, serving us breakfast and getting us off to school was in the hands of servants. Maybe that was the reason. We never at any time spoke at home of punishment at school because we would have been ashamed, and it would have only meant admitting that we had been at fault.

I was away from Belvedere from 1922 to 1924, my parents having sent me to Germany in furtherance of my education. They wanted me taught music and thought mistakenly that I had a talent for painting. I returned for one final year, 1924–25, with very much widened horizons and was something of a curiosity to my fellows, wearing as I did a trilby hat. The few times I was biffed in that final year hurt my pride more than my hands. I sympathise with those charged with teaching us in that final year. It needed strength of character and the ability to inspire affection and respect to keep big sixteen- and seventeen-year-old boys in order. The Rector, Fr Michael

Quinlan, a highly-strung man, was constantly expelling boys, telling them in class: 'Go home. Don't come back here to-morrow', but the miscreant would turn up grinning the following day, and Father Quinlan would only turn up his despairing eyes to heaven.

Much of my memory is of small boys racing round the playground like mad things during the luncheon break. One suffered in one's early years from a certain amount of bullying by bigger youngsters, big brutes of ten and eleven. It was not what they actually succeeded in doing to you, for there was always a cleric on duty to break up scuffles if they got too rough, but what they threatened to do, expressed in blood-curdling tones and with appropriate pantomime, signifying arms being twisted out of sockets. The remedy was to make friends with a boy bigger than the bully, and take your stand beside him when danger threatened, prepared at a moment's notice to call on him for help. Unfortunately, sometimes at the critical moment his attention would be attracted elsewhere, and he would run off when most needed. All you could do then was run yourself or stand and fight.

The squash-box was quite an institution. It was a two-feet-wide aperture between the chapel and the gymnasium, and about four feet deep. A cry would suddenly be raised: 'Put Murphy in the squash-box.' Murphy would be seized, thrust into the aperture by willing hands, and as many as a dozen would form in a long line squeezing against him. You soon learned counteraction; if you had not, your ribs would have been broken. You simply put one foot and one straightened arm against the drainpipe at the far end of the squash-box, and with your free hand and foot kicked and punched the boy nearest to you until he, pressed by his companions on the one side and assaulted by you on the other, madly fought his way outwards and thus broke up the whole line of persecutors.

The fact of physical punishment loomed very large in our school-days. I blame no one: it was the system of the time, accepted by teachers, parents and pupils. I feel however that I should say a final word. Patrick Pearse, writing of St Enda's, said that one must always remember that one is dealing with boys, not with cherubim. I would add a gloss. In later life the one-time schoolboy should remember that he was being taught not by archangels, but by fallible human beings.

One of Belvedere's virtues in my time was that the classes were small, varying from twenty to thirty boys. It meant that a teacher, had he the inclination, had also the time occasionally to sit beside you and show you how to do a difficult sum.

Although our teachers gave us a thorough grounding in religious doctrine, it was strangely enough from a lay brother that I learnt the virtue of charity. There were two lay brothers in Belvedere in my time, and I never saw anyone, teacher or boy, speaking to them.

You glimpsed them occasionally going silently about their duties. One of them, the benign Brother Purcell, presided over the sale of biscuits and sweets in the tuck-shop, a cubbyhole under the Senior House stairs, during the half-hour recreation we were allowed. I, a ten-year old, had put down my penny for six caramels, and he spoke to me, the one and only time I ever heard him speaking. 'Why', he asked 'are you always so quiet, standing still, not running round like all the others?' 'Ah,' he admonished me with a smile, 'you're far too gentle.' He added an extra caramel to those which I had bought, and dismissed me by turning away. It was the only time at school which I can remember that any adult manifested a personal interest in me, and I believe that in that one half-minute Brother Purcell taught me by example the lesson that in one's lifetime one should try to sprinkle kindnesses, however small, like confetti. It is strange to me that I have remembered that kind word for sixty-two years, and have quite forgotten all the exasperated roars and sarcasms of our teachers in class.

I feel myself in Belvedere's debt for the excellent grounding I got in grammar in four languages during my years in the Junior House, and for the fact that in my final year I was taught by a young cleric, Eugene Coyne, the only teacher I encountered at school who had a genuine liking for English Literature. I was also given a basic knowledge of many diverse subjects, taught the discipline of study and given the companionship of numerous children of my own age, of which I have been reminded over the years by being stopped from time to time in the streets by some grinning stranger who identifies himself as having shared woes and joys with me many years ago.

THIS BELVEDERE

A very gratifying feature of recent years is the decrease in the number of 'excuses.' These excuses, unless really necessary, let it be said in the most friendly spirit, do much harm, and parents who write them easily cannot complain if, a few years later, their sons fail in exams., on which so much depends.

'Class Notes', The Belvederian, *1909.*

Leaders of movements in every age have testified to the influence on their followers of a motto or slogan. The motto or slogan crystal-lises into a few words the object of the movement; it clinches the indecision of waverers, it intensifies the loyalty of adherents, it acts as a spur to greater activity in the cause. For these reasons, a motto has been chosen for the College.

Editorial, 'By straight paths', The Belvederian, *1933.*

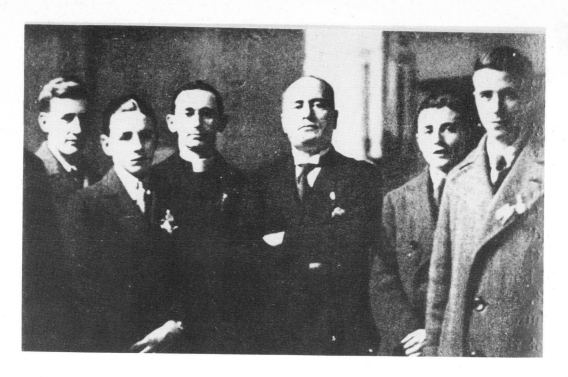

SIGNOR MUSSOLINI RECEIVES THE IRISH PILGRIMS.
A. Fogarty, B. Smith, Rev T. F. Ryan, S.J., Signor Mussolini, R. Dunkin.

It was during these last few crowded days that we were privileged with an audience with two very famous personages of Rome. One was Signor Mussolini and the other was the Father-General of the Jesuits.

Raymond J. Dunkin, 'The Aloysian celebrations at Rome: 1926', The Belvederian, *1927.*

Rule of life for students of Belvedere College S.J. Dublin .
Chief virtues to be cultivated: (1) piety, (2) purity, (3) charity, (4) humility, (5) obedience, (6) reverence, (7) gratitude, (8) truthfulness, (9) honour, (10) temperance, (11) manliness, (12) industry. Faults to be avoided: (1) dangerous companionship, (2) dangerous conversation, (3) dangerous books, (4) cursing, swearing, profane language, etc., (5) idleness, (6) human respects, (7) meanness, (8) ungentlemanliness.

Diploma of admission of Belvedere students to the Archconfraternity of the Sacred Heart. Quoted in Lambert McKenna, S.J., Life and Work of Rev. James Aloysius Cullen, S.J., *London 1924, 400-02.*

Twenty-five Years in Belvedere

WILLIAM C. FOGARTY

In 1909, when I came to Belvedere, we had scarcely two hundred pupils; and the school-building was less than half its present size. Of the quadrangle, now, as we know, a cemented playground, only the fountain remains unscathed: gone is the neatly-planned garden, with its four grass plots, its paths, its many flower-beds. There, at lunch-time, the boys were supposed to keep to the main path that bounded the square; and anyone breaking this rule was, if detected, ordered to stand for a while in silence near the fountain, where he was taunted by his fellows, who, very often, had, just for fun, elbowed him into the flower-beds.

The curriculum, too, was different: we were still under the Inter-mediate System; we had not yet tried the Direct Method; and compulsory Irish had not been introduced.

My first impressions of Belvedere are still fresh and have been modified but little by subsequent experience. From the start, I was struck by the confidence reposed in the masters, not only by the Community, but also by the boys; but, till I learned to appreciate it, the amount of freedom allowed to the pupils outside the classrooms — an invaluable foretaste of a world in which they would have only their own sense of honour to rely on — came as a shock to one trained on the Continent, where the boys are never trusted out of sight of a teacher, or, at least, of an usher (*surveillant des études*). Our boys were above the average, especially in their relations with the masters, whom they always treated respectfully, but without a trace of subservience or fear. And yet they were still boyish enough to dodge their work occasionally, trusting to luck to get off scot-free; but should Nemesis overtake them, they would submit stoically and bear no ill will. They were candid too. As thus: 'How much of the French author do these boys prepare at home?' enquired an inspector, struck by good or bad answering — I forget which — in a class where, as usual, the boys considered themselves overburdened.

'None, I fear,' said I. 'But wait; let us try: you may take their word.' Turning to the class, I questioned them individually. They all replied 'No,' except one who murmured diffidently: 'Well, an odd time, when my other work is done.' The inspector smiled, and went.

William Fogarty

To induce the pupil to conform to the standard expected of him, the teacher has often to exercise tact, cajolery and ingenuity, seasoned possibly with a soupcon of assorted threats.

For instance, a class about whose prospects I was much concerned had in it a budding politician who talked some malcontents into allowing him to head a deputation to the Rector (Fr John Fahy) to complain that I was giving them too much homework. When the Rector mentioned the matter to me, he agreed that it was a storm in a teacup, but suggested a slight concession to placate the angry *plebs*. When I met them again, the lads comported themselves like heroes who had vindicated their claim to the Rights of Man; but seeing that I looked hurt — perhaps disheartened — they soon became uneasy. So, I let them suffer the torments of suspense and remorse till I thought that the psychological moment had arrived. Then I said:—

'You all want to get your examination, but some of you won't exert yourselves. Shall I lessen all the work and permit you all to suffer the consequences?'

'No,' I went on after a long, doleful pause, 'that would only penalise the industrious and pander to the idle. I'll adopt a modified Dalton plan: I'll set you as much as I feel able to deal with. Those who wish to, may try to keep up with me; let those who don't, go as far as they please. But for them I accept no responsibility. They deserve to fail.'

80

Within a week every one of them was doing, quite willingly, far more than he had ever done before.

There were others too, who, though very doubtful, might have a chance if only they could be stimulated. So, singling out the weakest, I bet him a penny that he would fail.

'Done, sir,' said he.

Well, he got going, and I lost. On re-opening day he came to me in the Masters' Room and said: 'Sir, my penny?' He received it with my congratulations and went off delighted. I never saw him again. He was not coming back to school: he had just called to collect his money. I learned afterwards that he had hung the penny on his watch-chain and boasted of his triumph over Mr F. That was about fifteen years ago; perhaps he is not quite so sure now.

An ambitious pupil, guided by an enthusiastic teacher, may rise very high. For example, about 1923, in a room where I taught French, but a few benches from me, four boys, guiltless of French, used to study History privately. To fix my pupils' ideas and mitigate the aridities of Grammar, I was accustomed to begin by talking about our author and his place in Literature. To my astonishment, I noticed that one of the aliens was more attracted by French than by History. Indeed, he wanted me to start a beginners' class; but the Rector, to whom I referred him, had to refuse. So, for the nonce, he went to a private tutor, and all summer struggled on alone. In the following September, he insisted on joining the only French class available — the prior claim of Irish having closed down the rest. Next year, he was able to keep up with two other Leaving Certificate candidates, though they had started long before him; and at the examinations in 1927, only three years after the French microbe had got him, he, the erstwhile historian, scored first place in French in An Saorstát.

The artist is interested in his work, not merely while he is doing it, but even when it is finished, and long after it has left his hands. He will go to look at it if he can. If he cannot, he will try to visualise it. Generally, that is the teacher's only resource; for once school days are over, the boys he has been so long and so closely connected with disappear, sometimes for years, perhaps for ever. Meanwhile, how they change! Frequently I am embarrassed when an old pupil greets me. If I do not recognise him, I fear to hurt him by saying so. With some innocent question I strive to obtain a clue to his identity; but only too often I fail, and have to go away unable to place him. Occasionally, however, he smiles at my hesitation, and, having perhaps challenged me, tells me who he is. . . .

Whether we think school humdrum or irksome depends upon whether we happen to be masters or boys. Always there are amongst us a fortunate few for whom the glamorous veil of retrospection or anticipations blurs the edges of reality and tinges its grey with

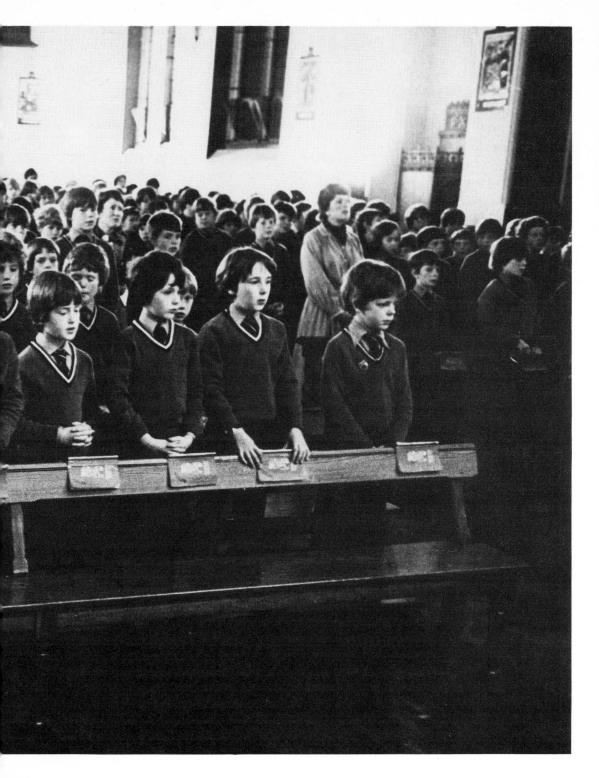

rose. And yet the life-story of some of us elders is punctuated with events that, important, extraordinary, tragic, or sinister as they appeared when they occurred, we would forget now if we only could. Thus, in my last year as a teacher in the Channel Islands began the persecution of the Religious Orders in France, with the consequent exodus to Jersey of Carmelite nuns, as well as the transfer, for safe-keeping, of private documents belonging to religious congregations. Just five years later, during my final summer in Canada, I carried on my class on the outskirts of Montreal amidst the smoke and sparks of a forest fire not far away. On my return to Ireland (and soon after to Belvedere) all was peaceful till 1912, when the Volunteer idea burst forth. That was followed, in 1914, by the Great War in Europe, and, in 1916, by our own Little War at home. But these catastrophes never interfered much with our school routine beyond forcing us, as in 1916, to suffer a day or two of extra vacation.

The guerilla war occasioned us in Belvedere some inconvenience and anxiety: on our way to and from school we had to dodge military patrols; and, as the Volunteers had a base near Findlater's Church, the frequent explosions of bombs, with the answering crackle of rifles, grew familiar to us even in the classrooms. The boys reacted normally. The youngest were frightened; the younger were engrossed and excited; but the Seniors were thoughtful, and frowned when it became known that one of the Fathers had been seen rushing out to minister to the seriously wounded. In military raids, which were common, two of our boys were captured: one was imprisoned in Mountjoy, but the other, poor Kevin Barry, was hanged. On the eve of his execution he asked Father Counihan to remember him to me. A bright, kind-hearted lad, he had only just left us and become a Volunteer.

Many others I knew in Belvedere have passed away... but all are, I trust, in Heaven; and all have to-day a special place among my Ghosts of the Past. I hope they don't forget me.

W. C. Fogarty, 'Twenty-five Years in Belvedere', The Belvederian, vol.10, no.3, 1935, pp. 11–17.

Schooldays 1900-1982

JACK BURKE-GAFFNEY

*In 1929 Jack Burke-Gaffney recalled his schooldays
at the turn of the century.*

Do you remember the Belvedere of 1899? You of my Vintage will
remember it. This was the Belvedere of the Little House; the old
Little House above the 'Messenger' office. One slid down the bannis-
ters, in spite of the nobby things put there to prevent it, that is, if
one could evade Father Gill, one fell off the bannisters at the end,
and knocked over Mrs Dalton's bucket of wet sawdust. I hope one
put the sawdust back in the bucket. Mrs Dalton was a good soul. Do
you remember what beautiful rooms those two were in which
Rudiments and Elements were housed? Elements was the long one
looking out on Denmark Street, and Rudiments the broad one
looking out towards the quadrangle. Even to my childish eyes it
seemed a shame that those beautiful walls should be splashed with
ink. The ceilings fascinated me and distracted my attention when I

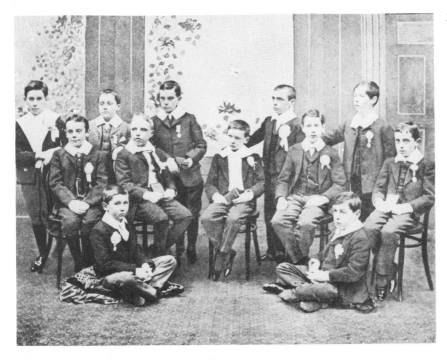

First Communicants, 1908

should have been learning how to write and how to spell. That is perhaps why I didn't. . . .

I remember how we used to get into school half an hour earlier than necessary in order to fight Britons against Boers! Fierce battles they were, in which the carpet black-board duster played a great part. The threshold between Elements and Rudiments (during class-time divided from each other by a folding door) was the frontier, and on one side ranged the pro-Britons and on the other the pro-Boers, and back and forward swung the daily battle, with a measure of bloodshed and torn collars and hot and ruffled heads until the neutral who had been posted to keep 'nix' came rushing in with his warning and a compulsory truce came about suddenly and peace reigned until the withdrawal of the common enemy. Meanwhile trophies captured were weighed against losses. These consisted of badges bearing the photographs of the leading generals of both sides, and small flags, British and Boer, which being planted in the coat lapels of their various partisans during the comparative safety of class hours, were surely marked down by an enemy for capture at the first opportunity.

Do you remember Saturday Gymnasium? The woolly smell of warm sweaters, hot red ears from pulling off a too tight one (shrunk in the wash, and handed down from a big brother) and the rubbery smell of shiny black-soled Gym shoes, are my clearest recollections of the first Gym Class of the new term. To complete the picture which is conjured up, add to it, Sergt Major Wright, changing behind the wings on the stage. . . .

Jack Burke-Gaffney, "'Do you remember?'", The Belvederian, vol.8, no.3, 1929, pp. 275–9.

FROM *THE BELVEDERIAN*

Many were the devices adopted by anxious Masters to give the Juniors an interest in their work, and to find for knowledge a more inviting entrance than the one some of us heard about and more than heard about, long ago when we were boys.

Thus, in one class there were three divisions – the 'Legion of Honour,' the 'Band of Hope,' and the 'Awkward Squad'. When a boy was declared worthy to be admitted to the Legion, it became the Rector's duty to publicly pin the Cross of Honour on his breast. The lad took his place amongst the chosen few, and, as idleness would lead to the loss of the prized decoration, fair, honest, industry was secured for months to come. The Band of Hope were aspirants for the Legion, and keen on joining it. The members of the 'A. S.' not only crept 'like snail unwillingly to school,' but did as little as they could when they got there, and were ever ready, when it was safe,

to act on the old, bad principle — never to do to-day what you can, by any chance, put off till tomorrow. To the honour of the class be it said that the members of the 'A. S.', operated on by a skilled and steady hand, gradually yielded to treatment, and by the end of the year had been restored to vigorous intellectual health.

'Class Notes', The Belvederian, *vol.2, no.1, 1909, p. 93.*

GEORGE O'BRIEN

George O'Brien (1892—1973), economist, historian, Senator and Professor of National Economics at UCD, was enrolled at Belvedere in 1908 at the age of sixteen. He spent two years there before becoming a student at UCD. He came to Belvedere 'knowing nothing at all about my own country'. This was because after four years in an English boarding school, Weybridge, he was, in his own words, 'a very good specimen of an English Catholic Conservative boy of sixteen'. James Meenan gives this account of George O'Brien's schooldays in Belvedere in his George O'Brien: a biographical memoir *which draws extensively on O'Brien's unpublished autobiography written in the 1940s.*

[When George O'Brien was enrolled at Belvedere] the prestige of the Jesuits stood at a peak in Ireland. It was still remembered that some of them had ignored episcopal instructions in the 1860s and had

Start for the Excursion

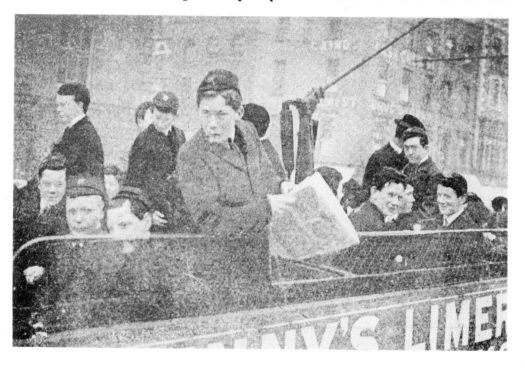

given absolution to the Fenians. For a generation they had been in charge of the only institution in the country where young Catholics could obtain something approaching a university education on terms that they were willing to accept. More recently, their schools had been remarkably successful in the public examinations for which all Irish secondary schools, Catholic and Protestant, entered their pupils. This was rubbed in by throw away assertions that success in examinations, however impressive in newspaper advertisements (including their own), was not their primary concern. That was the formation of character according to the historic mission of the Society since its foundation. Their labours were directed towards the preparation of their students for the responsibilities which Home Rule, 'only around the corner' in 1908, would bring. As their day school in the capital city, Belvedere was large and bustling. It had (with great justice) a high opinion of itself.

It was a higher opinion than George was prepared to concede. To begin with, at least, he was not impressed either by his teachers or by his fellow students.

Meenan quotes from O'Brien's diary this account of Father John Mary 'Bloody Bill' O'Connor.

He was 'the outstanding figure among the Jesuits: a great judge of character of boys and young men and a striking personality whom I found very kind on occasions when I needed his help'. This was high praise from one who was always fairly balanced in his assessment even of those with whom he was on terms of friendship. It is not surprising therefore that these expressions of praise are followed by what seems a chilling summary. 'He was a peculiar combination of worldliness and saintliness. I suppose his shrewd worldly wisdom was harnessed AMDG.' No doubt: the combination was freely and generously given to generations of young people in their early perplexities. . . .

In later years, George attached great importance to the two years in Belvedere. They were a vital link between the years in England and the years in University College. He had gone to Weybridge already far removed from the assumptions and ways of thought in which his contemporaries were reared. This detachment was increased by Weybridge. Belvedere narrowed, though it did not close, the gap. There he learned, without being so taught by anybody in particular, that he had a country whose interests might be very different from those of Great Britain.

All this may be summed up by one incident. A school friend brought him to the Abbey one night. It was his first visit. 'It was typical of the detachment of my family from nationalist Ireland that

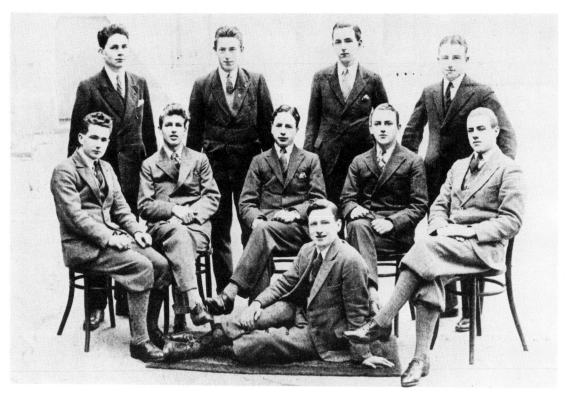

The Prefects, 1927-28

J. Callaghan, L. Murphy, B. O'Herlihy, D. Murphy,
T. Hyland, N. Stokes, D. Mulcahy, E. May, B. O'Reilly,
R. Sheridan.

they had never been to the Abbey and, if they had been, would certainly have regarded it as a joke'. Richard O'Brien's interests had their limits. The play George saw was that maker of rebels, *Cathleen ni Houlihan*. It did not make him a rebel, then or later. It did make him a nationalist, certainly a highly constitutional nationalist of a type that was soon to be out of date, but a nationalist nevertheless.

Nothing in the nature of revolutionary ideas ever came my way.... The main current was parliamentary nationalism derived from O'Connell through Parnell and the Irish party. Social problems, apart from the relief of congestion, occupied no part of our attention. The clamant problem of poverty in the slums by which Belvedere was surrounded aroused no curiosity or indignation. Nor were we interested in the great social experiments that were being made by the Government at that very time. We were Whigs rather than radicals. If Home Rule had been achieved in those years, the Irish Parliament would have been a very conservative and respectable assembly — a Catholic version of Grattan's Parliament. It would have been like a meeting of the Repeal Association held in the Old House in College Green.

90

He was at Belvedere to prepare himself for University College. The regulations then in force, long since discontinued, enabled him to spend his first year preparing for Matriculation and his second in preparing for First Arts. These were exalted quarters in which the seamier side of Irish education, as portrayed by Conal O'Riordan in *Adam of Dublin*, was unknown. Throughout his later life he was deeply conscious of his debt to the Jesuit system of education.

On the educational side I profited from my new school, especially in English and Latin. I experienced a taste of the great Jesuit literary tradition that had been absent at Weybridge....

There was one other part of the years at Belvedere which he felt deeply enough to recall.

I think I matured considerably. I experienced something in the nature of a conversion on the spiritual side of my life. In my last years at Weybridge I had become very lax and slack in my religious duties....

He did not, he says, derive any guidance from Belvedere 'where very little religious instruction was given except to the younger boys'. The reason was not the absence but rather the pervasiveness of belief.

Bidding good-bye to
Arthur Cox

The apparent lack of emphasis on dogmatic instruction really reflected the depth of underlying assumptions that were never questioned. . . . Certainly, nothing happened in Belvedere to weaken or interrupt the Catholic influences which had moulded me in my home and in my previous schools. If I was lax it was in practice, not in faith; and my laxity was entirely my own fault. In the sphere of religion, my youth passed without controversy or conflict.

In later life he had no doubt about the greatest gift he received from Belvedere. In his first year there, the Debating Society was established by Father O'Connor. The first auditor was, almost inevitably, Arthur Cox. The committee was composed of George, E. T. Freeman, Andrew Horne and Noel Purcell.

It met on Friday evenings and I do not think I missed a single meeting for the two years I was in the school. It was here that I first learned to speak in public without stagefright or embarrassment, and it was in preparing my speeches that I began to learn something about current Irish politics, on which I had been hitherto entirely ignorant. . . .

The English accent soon faded: all too soon he was to lose the self-assurance. There were two things that he learned once and for all from the Belvedere debating society. One was a fluency and clarity which was never to desert him through years of speaking and debating. The other was less happy. In his first year, he had in some way fallen foul of the mood of the debating society and had sat down in silence at a debate in which the other speakers had been loudly applauded. The reason is not given in his recollections; and, whatever it was, it did not prevent his election as auditor. But it was one of a number of little things which were stored up and were to be remembered in less happy days.

This bitter experience possibly had the result of making me a little bit suspicious of people generally. I have never ceased to expect a hostile attitude; and that very expectation may have bred a defence mechanism which reinforced a natural shyness.

James Meenan, George O'Brien: a biographical memoir,
Dublin 1980, pp.13—21 passim.

JAMES WHITE

James White, former Director of the National Gallery of Ireland, was a pupil at Belvedere in the 1920s.

The greatest problem in the field of education in Ireland today is the

92

fact that teachers receive little instruction in art appreciation. Thus, not only can they not impart it, but they will almost certainly fail to instil a respect for matters of art in the minds of those they teach. In many cases they will, perhaps unknowingly, create a sense of aversion to every aspect of art. I remember a teacher who used to repeat at the least opportunity: 'All art grows on a dungheap'. I have lain awake many a night recalling the fact and wishing that I had had the wit to reply: 'So does everything we eat'. I also remember the sense of awe created in the minds of my fellow-Belvederians at the fact that Father Jack Hanlon, then a most normal schoolboy, was also a painter. Apart from schooling generally, I remember Belvedere with gratitude for debating societies, plays, operas, an interest in poetry (Father Thomas Counihan used to make us compose free verse), the Bicycle Club, tours of factories and, of course, games. I never recall anyone except Father Mathias Bodkin mention art in any form and that was after I had left school and had met him in one of the O.B. societies.

James White 'Art, youth and Ireland', The Belvederian, *vol.20, no.2, 1963, pp.5—7.*

FRANK O'HOLOHAN

In The Belvederian, *Frank O'Holohan recalled one winter's day as a pupil in Belvedere, 15 January 1941.*

I was sixteen years of age and glad to be back at school after the boredom of the long Christmas vacation. The constant menace of the War, with its advances and retreats, combined with the numbing effect of total rationing made life at home very tedious and I was glad to be back at Belvedere, even if the school heating system was faulty and the students and teachers shivered through the long periods in cold classrooms.

Stamping our feet to keep warm, we stood in small groups in the school yard as we waited for the school prefects to unlock the great main doors that led to our classrooms. The usual horseplay was going on among the younger boys, pushing and shoving each other around, as we older students watched with amusement the schools Thersites, who cursed all the prefects by name, then went on to slander the teachers of the college. 'Don't forget this is the school's centenary year,' a wit called out from the crowd of listening boys.

We were never to know what this roughneck had to say about Belvedere's *annus mirabilis* because the burly figure of the Prefect of Studies (Fr Rupert Coyle), hove into sight. He had a near-legendary reputation as a third generation Belvederian, a Rugby ball-player of awesome records and the possessor of a dominant stare of potent power. He was not a man to be taken lightly and we as students

knew this from painful personal experience. Ignoring the falling snow, he consulted his watch and waited for the bells of the nearby St George's Church to toll the hour. With the first chime of the bells, he raised his hand and with an imperious wave he gave the signal for the doors to be opened.

As we had expected the central heating system was barely on. The classrooms were cold and damp and the teachers and students, as if pre-advised, were dressed for the classroom as if they were outdoors.

The usual rules of deportment were ignored and many of the boys sat huddled in their desks with their hands burried deep in trouser pockets to keep warm.

During the second period the sullen mood of my classmates was changed to joy by the sight of a steady downpour of snow. We knew from past experience that the combination of severe weather and the breakdown of the school heating system could persuade the administration to close the school at midday. After the first recess our hopes were justified and the glad news spread like wildfire that we would be free at noon to scatter to the heated comfort of our respective homes.

The last class of that day finished in a pre-holiday mood. The falling snow outside the classroom and the chill in the building conspired to break down the reserve that existed between the teacher and ourselves. The Jesuit teacher sat among us in a relaxed posture and in a good-natured manner told us of the plans made to celebrate the school's centenary year. Special emphasis, he told us, was being placed on honouring the school's distinguished students of the past.

Eager to avail ourselves of the break in school routine we plied him with questions about the history of Belvedere College. Besides being interested in his information, most of us liked him as a man as much as we respected him as a priest. . . .

The relaxed holiday mood continued, as our teacher began listing the names of some of Belvedere's famous graduates. Our teacher's interests must have been mainly literary, for only the greats in that field were stressed. He ignored the famous in medicine, law, and the Army. He told us of well-known Old Belvederians like Edward Martyn (1859–1923), the cousin of the writer, George Moore. He mentioned that Martyn was the first to conceive of the emergence of a National Theatre as a part of a political and national renaissance. It was in his house in Loughrea that the efforts of Lady Gregory and W. B. Yeats were to combine with Martyn's in the plans for the formation of a National Theatre.

We were interested in these literary reminiscences, perhaps because up to then we had only known our teacher as an exponent of Caesar's *Gallic Wars* and Virgil's *Aeneid.*

Encouraged by our attentive interest he went on to tell us of another famous Old Belvederian. The poet and patriot Count Joseph Mary Plunkett (1888–1916). He was the youngest of the seven who signed the *1916 Proclamation of the Republic,* but twenty-nine was not considered young in a year when, in Ireland as elsewhere, much younger men fought and died 'at some disputed barricade'. . . .

There was a silence in the room when the master finished talking. The only sound was the softly falling snow against the window panes. The silent falling flakes were a fitting refrain to the sombre mood that the account of Count Joseph Plunkett's death had induced in the listening students.

96

The teacher was quiet for some time, then, rubbing his hands and pressing them between his knees, he looked directly into the faces of the boys that surrounded him. 'Do any of you know the name of the famous writer who is being buried today in Zurich,' he asked. He seemed satisfied by the blankness that showed in the faces of his listeners. 'His name was Joyce,' he said, 'If you don't know it now . . . well, you are in good company. You will remember the name because you are going to hear it again. He was a student of Belvedere, some say the cleverest student this college ever produced . . . cleared the board of every prize the school could offer, and yet, he was one of those very intelligent men who still manage to be very unintelligent about religion.'

Someone at the back of the class started to ask a question but the school bell cut short his query. The class finished in the noise of slamming desk lids as students collected their texts.

Frank O'Holohan, 'Belvedere and Zurich', The Belvederian, *vol.25, no.2, 1978, pp.99–101.*

FROM *THE BELVEDERIAN*

Anon. may have spoken for more than his own generation of pupils with this contribution to The Belvederian *in 1946.*

The Listener

'Can any one hear?' thought the miscreant,
 As he brushed by the office door.
And his feet in the silence shook and shuffled
 On the corridor's unfriendly floor.
And a sound from Rhetoric classroom
 Fell on his listening ear,
But no other sign of movement
 That need give him cause for fear;
For no one answered the miscreant —
 No voice from the room within
Came to shatter his nerves and the silence
 With the awful words: 'Come in.'
So back to his class-room gaily,
 For the moment free from care,
To answer the inevitable query
 With a 'Sir, there was no one there.'

Anon., The Belvederian, *1946.*

DESMOND FORRISTAL

The playwright, Desmond Forristal, was a pupil at Belvedere in the 1940s. He entitles this essay, 'Memories of a professional bridesmaid'.

Every playwright should have had some experience of appearing on the stage. It is said that Shakespeare used to carry a spear in the productions at the Globe Theatre and was occasionally allowed to speak a line or two as Third Murderer or Fourth Citizen. I too have had my brief moment of glory. It was in the 1945 Belvedere production of *Ruddigore*. I was a professional bridesmaid. Fourth from the right, second row.

Ruddigore is not one of Gilbert and Sullivan's best-known works. In fact, not to put too fine a point upon it, it is one of their least known. But second-rate G. & S. is still streets ahead of most of its rivals, both musically and dramatically. There was drama, poetry, orchestral music, solo and choral signing, movement and dance, not to mention the arts of the scene designer and painter. As an introduction for youngsters to a cross-section of the arts, it could hardly have been bettered.

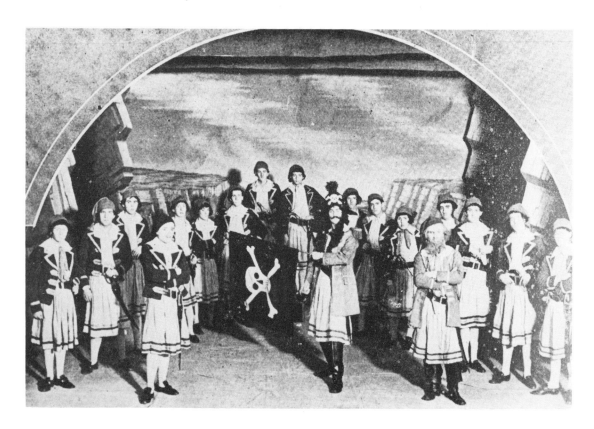

98

The producer that year, as so many other years, was Fr Charlie Byrne. I had a passable voice and some ability to read music. For a heady few days he actually considered me for the role of Dame Hannah, who had a whole song to herself in Act I and one half of a duet in Act II. But the days passed and another was chosen. I was relegated to the ranks of the professional bridesmaids (the adjective is Gilbert's, not mine) and on the whole was more pleased than disappointed at being spared the ordeal of instant stardom.

The early music rehearsals were dull and unmemorable. When we got on stage, things brightened up. Each bridesmaid was assigned a boyfriend, one of the gauche fifth- and sixth-year boys of the men's chorus, who was to act as our partner in the various dances. The choreography was not ambitious. I succeeded in mastering the basic all-purpose Gilbert and Sullivan shuffle (left foot swings right followed by right foot swings left) and it has stood me in good stead in rehearsing many a parish pantomime. A few of the nimbler spirits were given special tuition for the minuet and one character actually got to dance a sailor's hornpipe; but these higher flights were not for me.

The pace really moved into overdrive with the dress rehearsal. Huge hampers were unpacked and poured out cascades of silk and satin and velvet and brocade. We bridesmaids had been told to equip ourselves with one pair of stockings (female) and one pair of high-heeled shoes (ditto). The rest came from the hampers — dresses, wigs, veils, bouquets, and other accessories. A small army of lady helpers prodded and pinned us into our finery, shortening and lengthening, letting in and letting out, adjusting headgear and applying lipstick and make-up. We gazed silently into the mirrors, struck dumb by the magnitude of the transformation.

The older boys were just as lavishly accoutred. Their costumes ranged over three centuries of history, including a spectacular Anglican Bishop in immaculate lawn sleeves and an even more spectacular Cardinal in scarlet *cappa magna*, played by a French boy named Jean who was rumoured to be a real Count.

The week of performances sped by in a happy haze. The problem of preventing bridally bedecked boys from galloping round the school and putting their high heels through their lace dresses was solved with elegant simplicity. Feed the brutes. Any time we were not on stage we were eating. Mountains of doughnuts were consumed, lashings of cream buns, acres of sandwiches. And somehow, in the midst of all the excitement, there was the realisation that we were all working together to produce if not a work of art then at least a pretty good show.

The final night ended in a blaze of glory. It was final for me in more than one way. My voice broke soon afterwards and I was never invited to tread the boards again. But my memories remain. I have

seen the enraptured faces, heard the applause ringing in my ears, felt the adoration of the multitude. Even an ex-professional bridesmaid, fourth from the right, second row, is entitled to recall these things.

MARTIN DOLPHIN

Martin Dolphin of 3 Syntax I published this parody on Tartary, 'If I were Lord of Belvedere', in The Belvederian *in 1964.*

> If I were lord of Belvedere
> Myself and Tony Doyle,
> The desks would be upholstered
> There'd be no work or toil.
> And in the yard ball games we'd play,
> From 10 to 2 would be our day,
> And for the buns no cash we'd pay;
> If I were lord of all.
>
> If I were lord of Belvedere,
> I'd give the boys their needs,
> Of comics, Dells and Classics too,
> Clustered as thick as seeds.
> And ere should wane the evening star,

I'd don my jeans and my guitar
And masters seven should draw my car,
Back home from Belvedere.

If I were lord of Belvedere
Matches every day,
To Lansdowne Road would summon me
And I would watch the play.
And in the evening film shows;
Of Harold Lloyd and girls and beaux,
And maybe Elvis now who knows,
If I were lord of all.

Lord of the halls of Belvedere,
Her stone walls dusky grey;
Lord of the rooms of Belvedere,
Yard, class, and red brick clay.
A flashing biffer for work not done,
Her trembling pupils, every son.
The class supreme, that's 3.S.I.,
Pays honour where it's due.

The Belvederian, *vol.20, no.3, 1964, p. 60.*

The Playing-fields of Belvedere

JACK BURKE-GAFFNEY

Schoolboys in Dublin have often been introduced to the geography of their own city when engaged in travelling to the sports grounds of rival schools for away fixtures. Belvederians may have had an even greater knowledge of the city because — being a city centre school without sports fields adjoining the college — they travelled to both home and away matches. Jack Burke-Gaffney, a schoolboy in the first decade of the century, recorded these reminiscences for The Belvederian.

Was it before your time that the playing fields were out at Finglas? In those days we played both Rugger and Soccer. Finglas was a long way out, a long, long way to go on the back step of somebody's bicycle, especially if the back wheel needed pumping. There was a shop on the way where you could get a penny-worth of magnesia, and they gave you a little spoon with it like a doll's spoon. You dug a

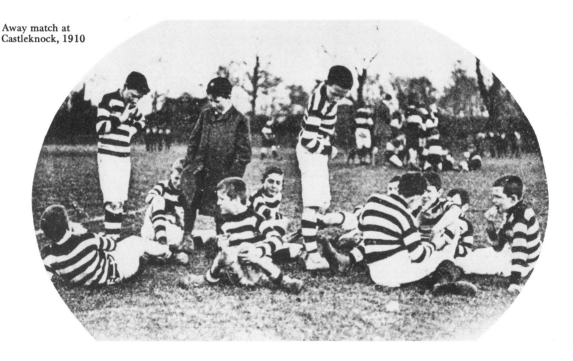

Away match at
Castleknock, 1910

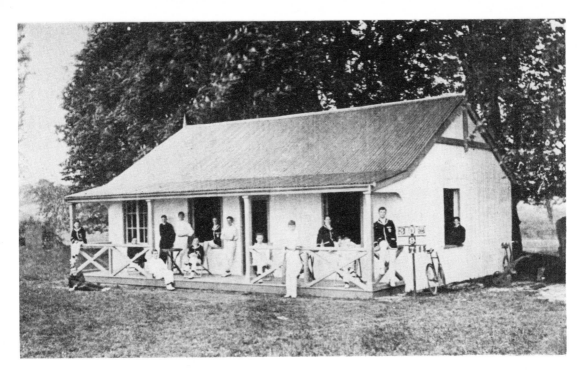

piece out of the oval-shaped box (it looked like an ointment box) with the spoon, and it fizzed on your tongue. A better plan was to wait until you got to the farmhouse near the ground and ask them — please would they lend you a tumbler, which they invariably did, and then you pumped into it from the pump in the yard beautiful spring water and spoiled it with magnesia — but it fizzed beautifully. The one whose penny it was naturally had first drink, and the smaller boy, whose penny it was not (it happened to be always myself!) didn't get a drink until the best of the fizzy part was gone — but in spite of that it was compensation for the long journey on a warm day.

I forget what year we moved there, but Croydon Park shall always live in our memories at any rate as the School Ground where we learned our football. . . .

I loved Croydon Park, and I think all your 'Vintage' did — in spite of the long walk and the slobland smell. . . .

Such pleasant pictures its name calls up! Autumn and the damp leaf mould smell in the drive, wet soft grass to tackle and be tackled in; soft watery skies fading into night as dim shadows still try to see the posts for a practice place kick. Comes Easter and the Cup-ties finished; the enthusiast in the holidays, hating to say farewell to Rugger, takes out a ball to punt about. It is already dry, and how light it seems, and how queerly it bounces on the ground already

hardening in the warmer days — and already sprouting feathery grass. Put it away again! The effect is disappointing. The vanished spirit will not be captured. It is folly to fret for it. The new is coming; take it as it comes — warm days, lazy days, butter-cups and daisies! What a delightful smell is the smell of new-mown grass! What a pretty place Croydon Park was in the leafy beauty of its summer dress — cricket — and the tea interval; stumps drawn at sun-down and home in the delightful cool. Does it come back to you? Do you remember the end of term concerts held in the pavilion and the long and serious talks of the future years of school life? It was there surely that one's schoolboy dreams were first visualised; they almost came true, only to collapse and subside, ephemeral illusions as empty, as unsatisfactory as a soufflé. But equally how sweet while they lasted! And above all, how comforting to recollect.

Jack Burke-Gaffney, "'Do you remember?'", The Belvederian, vol.8, no.3, 1929, pp. 275-9.

Hurling team, 1919

E. Morris, P. Clarke, K. O'Farrell, G. McAleer, S. McEvoy, P. Maher,
L. Devereux, H. Kelly, K. Barry, J. Murphy, C. Crean, D. Travers, J. Cummins,
E. Davy, T. Moriarty.

104

M. O'Rahilly, T. Hyland, T. Gleeson, M. Walsh,
J. McGrath, D. Mulcahy, D. O. Herlihy (Capt.), J. Byrne, E. Moy,
G. Morgan, B. Smith.

Showing how it's done

B. Miller; J. Byrne; G. Quinn; C. Nolan; B. Quinn; Mr. J. Boucher.

105

BOB O'CONNELL'S SECRET CUP MEDAL, 1924

Bob O'Connell claims that the Black and Tans were instrumental in sending him to Belvedere. His family came from Westmeath to live in Gardiner Place in Dublin on Armistice Day, 1918 and along with his brother, he was sent to St Patrick's National School, Drumcondra. During the winter of 1919-20, he and his brother had to walk to school along the Drumcondra Road at a time when the Dublin Brigade of the IRA used Drumcondra Bridge and the Canal Bridge to ambush the Black and Tans who used this route each day to come to the city from their camp in Gormanston. Such dangers precipitated his parents' decision to send him and his brother to Belvedere in September 1920. Bob O'Connell's hope was that his new school would have a hurling team as it was a sport which he had enjoyed at St Patrick's. Belvedere had: but in those years, hurling was the summer *team game at Belvedere, taken up only after the Rugby season had been concluded. Bob became vice-captain of the hurling side and he recalls that they played against most other colleges but 'without conspicuous success'. (Some few years later, the GAA rules barring the participation of Rugby players in their games resulted in Belvedere abandoning hurling.) In that September of 1920, Bob was faced with a decision: to begin a new football code — to play Rugby, or not.*

The decision was made for me by Father Tom Counihan who sent for me and ordered me down to Jones's Road. I went down that evening to practice and immediately, or certainly within half an hour, fractured my collar bone. This effectively put paid to my chances of getting on the famous Junior Cup Team of that year, one of the most famous J.C.T. XVs ever in Belvedere, having all the brilliant players who afterwards took part in the senior victories two years later. Aiden McGrath, Jimmy Connell, Jimmy McHenry, Joe O'Mara and a host of others formed this junior team which remained undefeated until the first match of the Cup series when they were beaten in Donnybrook, three points to nil, by Castleknock. I suppose that it was on that day that I first experienced the 'pain of loss': standing on the mound in front of the Bective pavilion after the match, and looking in the gathering dusk, at the empty field with the occasional seagull, I wondered if it would ever be possible that the match could be replayed! The impossible did not happen and I learned that day that in Rugby football, anything can happen, and that even the best team may, at long last, be defeated.

The following season I was over age for the J.C.T. but was anxious to play for one of the school teams but again a serious illness intervened and 'medical advice' determined that my return to the game would have to be postponed for twelve months. That season, as a

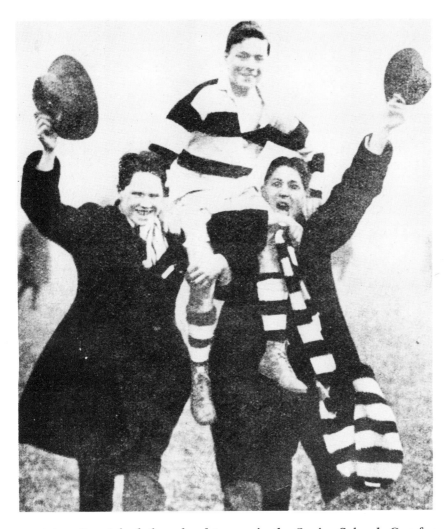

Eugene Davy, captain
J.C.T. Cup winning team,
1919

spectator, I watched the school team win the Senior Schools Cup for
the first time ever, defeating Castleknock in the final. I can remem-
ber the delicious joy in Lansdowne Road on that occasion. We
schoolboys swarmed on the two-horse brake, festooned with black
and white ribbons, flags and banners. The young players wore their
rugby caps — all of us cheered ourselves hoarse on that triumphant pro-
cession from the ground, down Northumberland Road, Mount
Street, past Trinity College, into O'Connell Street, and up to Belvedere
where all the school, including our teachers, had assembled to greet
the winning team. That evening at the festive banquet, toasts to our
captain and to our trainer, 'Bloody Bill' O'Connor, were drowned in
lemonade. Then came the aftermath, some days off from school, the
photographs, the excitement, and the inevitable anti-climax: for me,
that was one of the happiest years of my life.

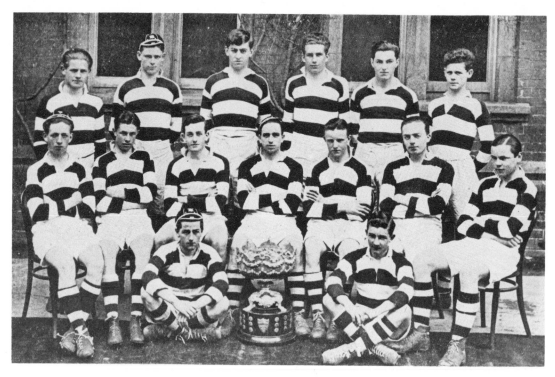

S.C.T. Cup winners,
1924

Standing — P. McAllister, P. Tighe, C. Carroll, N. McAuley, T. O'Connell, E. Crosby
Sitting — D. O'Connell, M. Roche, E. Doyle, K. Keohane *(Captain)*, J. Moran, A. Flood,
D. Moran
On the Ground — N. O'Rahilly, J. Arigho.

The following September, being my final year in Belvedere, my
ambition was to be selected for the senior team: it was a promising
side — we were the Cup holders — and many of the previous year's
team were again available. Imagine my disappointment when, early
in September, my doctor again advised my parents that I should not
be allowed to play. I went to 'Bloody Bill', Fr John Mary O'Connor.
He listened to me for a while and said that he thought the doctor was
wrong — but that he felt it might be wise *not* to inform my parents
that I was going to play. 'Now', he said, 'down to Jones's Road for
practice.'

I played throughout that season and had to give many excuses to
my parents as to why I had to travel here and there: I said that I was
a 'bag man' and I even had my togs washed by another boy's mother!
When I was injured, my story was that I fell off a bus or got hit by an
apple. Belvedere had another good season; we won the Cup in 1924
and I was on the team. The scenes of triumph at Lansdowne Road
were repeated, and my ambition of winning a cup medal had been
fulfilled. Some ten days later my father sent for me. He had received,

inadvertently, a photograph from the *Irish Independent* of the winning school's side — and there I was prominently in the back row! The expected explosion did not take place. He said, sadly: 'Why didn't you tell me, I would have loved to have seen you play.'

JOHN McCULLAGH

Gymnastics was the first popular sport in Belvedere. It flourished at the turn of the century. John McCullagh in The Belvederian *of 1905, looked back to an even earlier period of Belvedere 'gymnastics'.*

In those days, although Dr Ling's Swedish system had been in existence for half a century, and Herr Bölscher and Dr Roth, in England and Germany, had for many years been preaching the gospel of 'rational gymnastics', physical education, as at present understood, was practically unknown. Of teaching there was none. The school supplied the apparatus, and the boys got on as best they could. The

Seniors at Boxing Drill

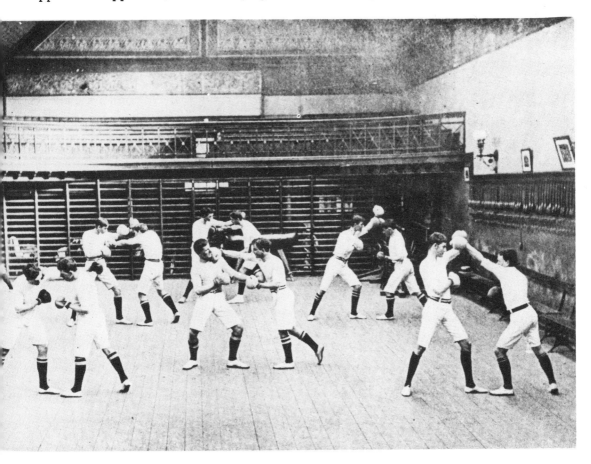

109

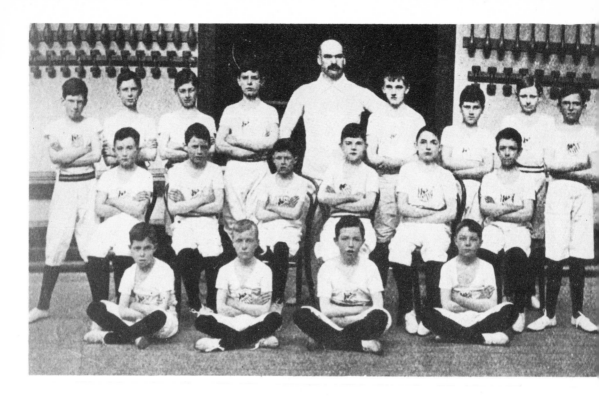

Gymnastic Class, 1912-13

more adventurous copied, or tried to copy, what they saw done in the circus; and their schoolmates in turn copied them.

As regards Belvedere, its first gymnasium can be best described as 'elemental' and its curriculum embraced boxing, carried on in 'F's' loft; apparatus work in 'D's' yard; and *anti-educational gymnastics* in the back garden.

What is now the quadrangle was then a garden; a long blank wall ran along where the Gym now stands; and the site of the present chapel and class-rooms was occupied by a range of stables. The room now used as a domestic chapel was then third of grammar class room. It is important to remember that *third of grammar* in the 'sixties' was of a very different type from the class so known at the present day. It consisted of nearly all the fourteen and fifteen year-olders, the more procを precocious of the thirteens, and the dunces of sixteen. In other words, it embraced all the disorderly elements of the school: *and the windows of their class room looked out on the garden.*

At the corner of the existing Gym there grew a mountain ash, which projected a long, horizontal, branchless limb over the back area. This limb could be reached by a jump from the area wall: and it was a point of honour for every boy who, on any pretext, passed through the garden, to do a 'voluntary' on it for the amusement of the third of grammarians. Such were the anti-educational exercises.

110

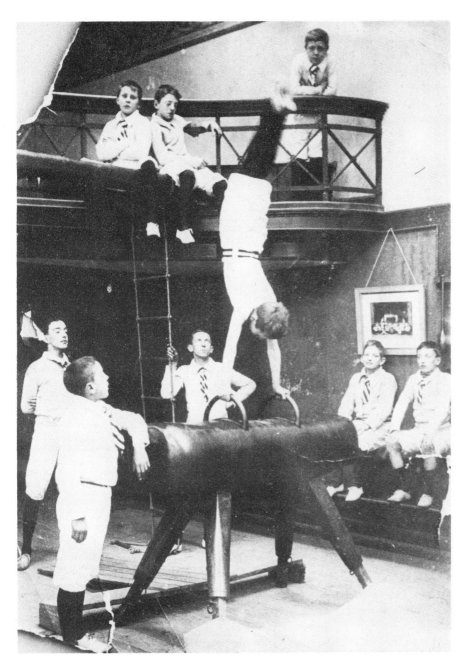

For several years all went on well; but at last, owing to a regrettable incident with which I was connected, the ash tree ceased to be available. One evening, in 1866, I was about to finish a rather good performance by a hock-swing. Just as I threw myself backward, I was horrified to hear a too well-known voice utter, 'Well, John!' As my

Exercise in the gymnasium, *c.* 1900.

111

head reached the lowest point of the swing, my eyes showed me the then Rector (Very Rev. E. Kelly) watching me from the steps; my knees let go, and I took a header into the area. But the Providence which watches over schoolboys intervened on my behalf by ordaining that I should fall on the Rev A. Greene, S.J., who was reading the *Osservatore Romano.* I flattened Father 'G.' tore the paper, but saved my skull.

That was the end of the first Belvedere Gymnasium.

The Belvederian, *vol.1, no.3, 1908, p. 147.*

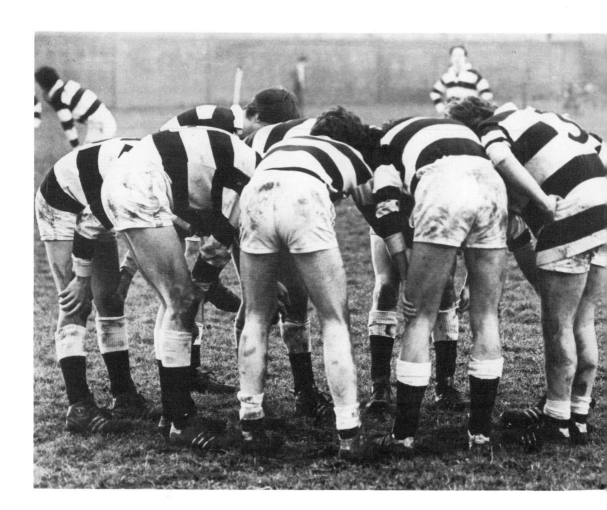

AFTER BEING BEATEN IN A CUP FINAL
(With apologies to Milton)

These lines concluded the Rugby notes in The Belvederian *in 1933:
the Senior Cup Team had been defeated by Blackrock in that year's
final.*

> When I consider fruitless labour spent,
> And all our toil, on that dark field and wide,
> And the one triumph which our struggling side
> Strove to secure, and heart's content
>
> Snatched from our grasp, we helpless to prevent
> The losing, though we gamely bravely tried —
> 'Doth Alma Mater blame us, luck denied?'
> I fondly ask. But, kindly, to prevent
>
> That murmur she replies: 'I do not need
> Either success or trophy; they who best
> Play out the game, they serve me best; my name
>
> Rests not on fleet three-quarter's dazzling speed.
> No, pluck, endurance, character's my test,
> And gallant losers are my lasting fame.

'Forward', The Belvederian, *vol.10, no.1, 1933, p. 133.*

THIS BELVEDERE

The main feature that strikes one on making a survey of its twenty
years' history, is the extraordinary manner in which Blackrock has
defeated Belvedere, year after year, without a single win on our part
to relieve the monotony. Blackrock has always been the danger
lurking ahead, and our yearly ambition was to lower their colours.
Yet some invisible fate seemed to be fighting against us and when
victory seemed to be almost within our grasp it was always inevitably
snatched away.
'A rugby retrospect', The Belvederian, *1923.*

Days without Wine and Roses

CONOR O'BRIEN

So many people want to polarise everything and everyone into tidy compartments. One is either capitalist or socialist, Catholic or non-Catholic, normal or abnormal. When I am asked if my schooldays were the happiest in my life and I emphatically say that they were not, it is assumed therefore, that I was miserably unhappy at Belvedere. Not so. It had its ups and downs, but mainly it was a period of living and partly living in an unburnished dawning of dull contentment.

The downs were certainly during my years in the Junior House. I was small and meek and a year younger than the rest of the class, so I was psychologically ravished each day by a satanic-looking Prefect of Studies who was distantly connected on his father's side to Robespierre. He was one of the last specimens of his breed — the absolute school despot, who wielded his black leather biffer on soft pink hands and hard oak desks with (it seemed to me) murderous

ferocity and thereby achieved miracles of discipline. When I had grown up (when I was in Third Syntax, that is) I discovered that this apparently sturdy descendant of Dotheboys Hall was, in fact, in almost constant pain from frightful stomach ulcers and was a kindly man when he wasn't in agony.

However, before these discoveries were made the Rector had decided that I must be 're-allocated' with boys of my age, so I heard the news that I was to mark time for an extra year in the Junior House with undisguised horror. I was not consoled by the rip-off of a prefect's badge, but that was another mistake I made about my *bête noire*. He treated his prefects with, if not quite the deference due to young men of pedigree, at least a recognition that he and they had a common purpose in life — the maintenance of law, order and straight lines up and down the stairs. So dedicated was I to this Gestapo role that I had little time for anything else, and thus was sown the seed of a science that I would gradually turn into a pure art form — getting by academically with a minimum of study.

Another honour that was heaped on me around this time was the title of Chief Altar Boy, a position that existed neither before nor after my tenure, and was a Jesuitical manoeuvre in the most specious sense of that term. I lived literally around the corner in Parnell Street and, while the advantages of this were obvious, the disadvantage was that I had no plausible excuse for refusing to be in Belvedere every day before dawn to serve a couple of Masses for priests on the staff.

On one such occasion I unwittingly, and with the best of intentions, tampered with the Doctrine of Transubstantiation in a way that put me far ahead of Vatican II, not to say Vatican III. I had done a time-and-motion study on the ceremony of serving first wine and then water to the celebrant and had calculated that several seconds could be saved if I mixed the two together. When I offered a cruet of faintly-tinted, unassuming rosé to Fr Charlie Byrne a look of bewilderment crossed his normally impassive and well-bred features. He hissed 'What is this?' and when I explained My Idea he got very tetchy and demanded that I get the proper libations at once. He then started Mass all over again, leaving out the Gloria, as they do in the Mass for the Dead. In the sacristy afterwards he turned to me and said in that immaculately pedantic way of his: 'And in what, pray, did you intend me to wash my fingers — lemonade?' He gave me a rotten part in the next opera.

My eventual move to the Senior House was a liberation of spirit that was exceeded only by the uninterrupted bliss of years of university. True, Fr Coyle was not exactly a man you could play around with: he exuded a praetorian authority merely by being present. His sense of justice was so finely developed that if he punished you, you knew you deserved it. So, although discipline was still a characteristic of seniors, it was now a discipline of habit, even self-imposition, rather than an exacted obedience.

Of course the atmosphere of those days was entirely different to what it is now. There as An Emergency going on in Ireland (the rest of the globe idiosyncratically referred to it as a World War), so self-denial and obeying rules were accepted elements of survival in our everyday lives. We thought nothing of walking to Cabra and back for a rugby match, or cycling to Blackrock, Terenure and even to Darkest Clongowes.

All this bred simplicity — naiveté even. There were dirty jokes, of course, but they were artless anecdotes in which toilets were the almost inevitable *mise en scène* and which would bore the pants off today's sophisticates. Sex was rarely talked about, the girls were galactic creatures who sprinkled the threshold of our imagination with fairy dust on the sidelines of Donnybrook. So, in our guileless terms, to have had sex only once in the year was another way of saying we were knocked out in the first round of the cup.

As for the Unspeakable Sin, it was never spoken about simply because we had never heard of it. Ah yes, you will say, that's because you were at a day school. A cross-examination on this point many years later of a group of my contemporaries at Clongowes confirmed that they were almost as ignorant as we were; almost, but not totally.

Likewise, we were untouched by drugs because there were no drugs; and drink, because of the strict enforcement by publicans of the age limit and the absence of off-licences, was virtually impossible

116

to obtain. I suppose smoking was the most daring perversion open to us, but even this was limited because of the great shortage of cigarettes.

I don't think it is possible to say that my generation was 'better' than the present one. The most one can do is to note differences and resist the temptations to set up an equation. We were, as I say, naive and disciplined, so we had few hang-ups. But we never did much thinking for ourselves, as students do today. Nor would it have crossed our minds to develop a social conscience. We were surrounded by some terrible poverty, but it wasn't 'our fault' so we felt little obligation to get off our behinds and do something about it. That sort of paralysis is much less evident today. During (and long after) the war we walked for mile after mile because transport was so restricted, but if anyone had suggested that we organise a walk for charity we would have thought him in need of custodial mental care.

I don't feel defensive or apologetic for what today might pass for prissy dullness. If rebellion, lust, and self-indulgence had been the common currency of our time, I haven't the slightest doubt we would have tried all of them on for size. Perhaps not all: I'm fairly sure we would have seen through the futility and exploitation of the drug scene and I'm certain we would not have tolerated vandalism. Our positive asset was a strongly developed sense of comradeship and a proper pride in our school. Some of my contemporaries carried on the Old School Syndrome into later life a bit too fervently, too exclusively, for my taste. Had it been possible, I think they would have married Old Belvederians.

What, then, did the Jesuits do for me? I believe they didn't pass on much knowledge, but effectively rearranged my ignorance. Which is a flip way of saying they taught me how to go on teaching myself for the rest of my life. They also gave us balanced and tolerant moral values. This was a priceless gift that helped so many of us to steer a steady course between the goody-goody hypocrisy of thirty years ago and the rudderless moral vacuum that young people are tossed into today.

My wife has a theory that a Jesuit education is a long fuse that detonates a gratifying explosion of erudition in later years. This is too subtle for me (on account of not having experienced my explosion yet), but I'm bound to say that an unusually high proportion of my classmates, who were apparently as thick as the floorboards, became astonishingly successful in their careers (I saw one of them cut his hand badly when he broke a Marietta biscuit in two; he is now a brain surgeon). Conversely, the chaps who won all the annual prizes (*A Garland of English Verse*, two free passes to the Savoy etc.) and who seemed destined to achieve greatness have, by and large, sunk without trace. Some, it is whispered, went into Trade.

Then there was the poor wretch who chucked in his legal robes

and became (oh, the shame of it!) a journalist. But that's another story.

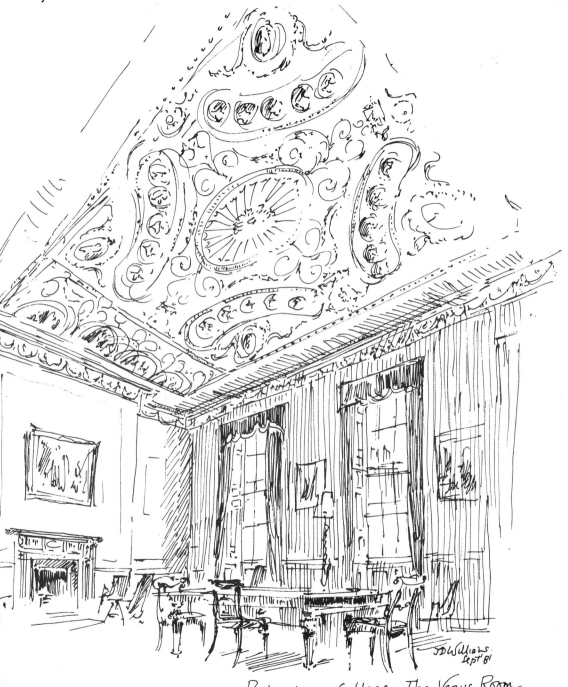

Belvedere College: The Venus Room
(1786-)

To Deserve the Title of a College - the Jesuits at Belvedere

PAUL ANDREWS

'We have acquired a large, beautiful house on a splendid site, such as may be worthy eventually to deserve the title of a college, provided we can find the men for it.' Fr J. Bracken, Provincial to Fr General S.J., 29 November 1840.

A school, like a bank, assumes a facade of massive stability, which masks the volatile nature of the commodity within, children in the first case, credit in the second. Belvedere, like any school, has had its moments of instability. It did not grow inevitably to its present shape. There have been times of crisis, and of deliberate free choices, which together go far to explain the present shape of the College. This chapter is an attempt to reconstruct that history of decisions, to see Belvedere from the inside; initially that means from the viewpoint of the Jesuits. It was they who freely decided to start a Jesuit school, decided whom to teach, what to teach them and how; also where to situate their school.

In May 1832 the five Jesuits in Hardwicke Street found themselves with an empty building. With the opening of the church in Gardiner Street, the chapel in Hardwicke Street had lost its first function, and was available. For what? The pomp and circumstance which attended the opening of St Francis Xavier's Church on 3 May was quite absent from the opening of St Francis Xavier's school five weeks later. The decision to use the old building as a school was curiously casual, but it had deep roots. Before their suppression in 1773, the Jesuits had been called the schoolmasters of Europe. Francis Bacon had advised: 'For education consult the schools of the Jesuits. Nothing hitherto in practice surpasses this.'[1] They had had schools especially in the south of Ireland: New Ross, Clonmel, Kilkenny, Cashel, Waterford; generally day schools, in towns. The most successful of all had been Fr John Austen's school in Saul's Court, off Fishamble Street, in Dublin; its pupils included Dr Daniel

1. Francis Bacon, *The Advancement of Learning*, Bk 1, 1846 ed, 167.

120

Murray, who as Archbishop of Dublin celebrated the first Mass in Gardiner Street Church.[2]

The 1832 Jesuits, still diffidently trying to recover continuity with the old, pre-suppression Society of Jesus, felt education to be central to their identity and vocation. In their vow formula, they had promised, as their successors promise today, 'a special concern for the instruction of children'. Pope Pius VII, resurrecting the Society in 1814, had given the service of education as his main reason for restoring it to life. The opening of two country boarding-schools, Clongowes in 1814 and Tullabeg in 1818, had gone only half-way to restoring the educational tradition, which had focused on city schools. The Catholic Relief Act of 1829 had raised the hopes and aspirations of Catholics, so long disenfranchised by the savage Penal Laws; but it had brought small comfort to Jesuits, since it was designed to eliminate them. All Jesuits in Ireland were ordered to register themselves with the authorities, and they were to have no successors. St Ignatius had prayed that his Company would never be free from opposition and persecution as only the bland and spineless could achieve such freedom. In view of the 1829 Act, Fr Esmonde, then Rector of Clongowes, was far from bland when he wrote in

Belvedere College from North Great George's Street, c. 1900. (*Lawrence Collection, National Library of Ireland*)

2. On Fr Austen's school, *The Belvederian* vol.18, no.2, 1959, 115 ff.

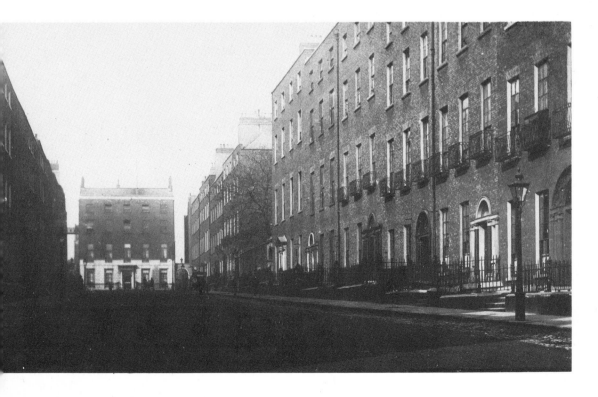

1830: 'No man should stir an inch from his post ... till our existence is consolidated — Public Schools in Dublin, Noviciate at home.'[3]

So in 1832, when Fr Charles Aylmer found an empty building available in the centre of Dublin, and the energies of his five companions not totally exhausted in the work of the new church, it was natural that he should think of a school. Fr Esmonde sent the news to his Provincial, Peter Kenny, who was reorganising the North American Jesuits: 'Mr Aylmer has commenced his day school (in a very humble way with, as I hear, only eleven or twelve scholars) in the old Chapel of Hardwicke Street.'[4] He overstated the number. Only nine boys enrolled on 12 June 1832; and within two years all of them had left. It was a start, a seed. It was not thought particularly important. The General in Rome was not even told of it until much later, although he was regaled with accounts of the first Mass in Gardiner Street Church. When Fr John Shine, its first Prefect of Studies, died two years later, the obituary spoke of his previous work in Clongowes, and of his services to the church in Gardiner Street, but not of the little school he had left orphaned.[5] The obituary of Fr Aylmer also spoke of his work in Clongowes and Gardiner Street, but made no reference to the school he had founded in Hardwicke Street.[6]

The fact that it was a Jesuit school was partly what enabled it to survive. As in all matters religious, there was and is a gap between Jesuit profession and practice; but the profession left its mark on Belvedere, and requires a second glance. It was a religious profession, a search for God in all things, not least in interior prayer. The three vows diverted Jesuits from the pursuit of money, of sexual pleasure, and of making a career. In themselves they constitute a protest against the common preoccupations of the city. Jesuit life has one great compensation: the mutual support which married people seek and normally find in one another, the Jesuit seeks and normally finds in the community of his brethren, who live together in a style which though not intimate, is supportive, not only in the tasks which the community shares, but also in the affection and companionship which they offer to one another, priests, brothers and scholastics.[7]

However imperfect the practice of these ideals, they matter more than the curriculum of Belvedere. Teachers are remembered for what

3. B. Esmonde to R. St Leger, 10 June 1830, Clongowes Archives.
4. B. Esmonde to P. Kenny, 8 July 1832, Clongowes Archives.
5. *Memorials of the Irish Province, 1814—1914*, 16.
6. *Ibid.*, 49.
7. Besides priests, the community has always included unordained brothers, men with a range of skills who over the years have been the housekeepers and administrators of Belvedere, cooking, cleaning, maintaining and, in recent years, teaching also. Scholastics are young Jesuits on their way to ordination.

124

they are more than for what they say. First, the reference to God. There have always been Jesuits here for whom God was the most important reality, and prayer the most important time of the day. They were not always able to convey to immature boys their sense of God. The Gospels are essentially for men, not for children; even adults do not easily find language apt to convey a religion of spirit and of truth. The religious instruction of young people tends to reduce the Gospel to a set of pieties, and to stress the externals of practice because the interior life eludes the atmosphere and language of the classroom. The Jesuits have always considered religious education the most central and important part of their work in Belvedere; they have equally found it the most difficult and frustrating; and this at every age.[8] We reproach ourselves for reducing the interior life, the freedom and flame of the Gospel, and the mysteries of our religion to a set of pieties and of catechetical formulas which are more easily taught. In spite of this, some of the freedom and flame was conveyed. The greatest delight of teachers was when a sense of God led boys to choose him as the lodestone of their life in the priesthood or the religious life, and not uncommonly among the Jesuits themselves. The number of vocations, especially Jesuit vocations, was the most convincing index of success in conveying a sense of God. Even for the others, who in no way aspire to a religious vocation, one cannot discount the effects of prayer. Evelyn Waugh wrote to his son Auberon at Downside, comparing his own adolescence at Lancing College with Auberon's opportunities: 'One great advantage you have on me is the contact with a place of prayer. Don't neglect that advantage. Your moral and spiritual welfare is the main thing of absolute importance.'[9] In Belvedere few boys saw the Jesuits at prayer except on occasions of public liturgy. They prayed and pray privately, as the Gospel recommends; pray for their pupils too, commending them through the Son to the Father, grateful that the work of their sanctification is shared by the Holy Spirit. The effect of that prayer is real, but known only to the Father.

The effect of the three vows is more easily documented. Jesuits have effectively shared their resources, and have normally left financial decisions to the superior. They have one moment of financial discretion, the moment called renunciation, when the Jesuit

8. Today's Jesuits find Religion the hardest class: commending the faith to clever boys primed with the sophistries of the media, whose freedom to withold assent is charged with the natural rebelliousness of adolescence. The Jesuits of 1907 felt the same; see the Provincial's remarks on visiting Belvedere that year: 'Earnest efforts should be made to secure better teaching of religious knowledge. The present difficulties are undoubtedly great, but the loss is a very serious one for the Society and the boys' (Visitation Book, Belvedere Archives).
9. Mark Amory, ed., *Letters of Evelyn Waugh*, London 1981, 466.

Reverend Fr. Rector,

 P.C.

In order to prevent any abuse in the use of bicycles, that might be a source of disedification to others, or a solid reason of scruple to ourselves, I beg of you to make known and to enforce the following regulations.

1. No one may have or accept a present of a bicycle for his own private use. If any such present be offered to him he may not accept it without first obtaining permission from the Provincial and then he may not receive it for himself but for the house in which he lives, and the bicycle is to be completely at the dispo sal of the Superior of the house for the use of the Community. N.B. As far as possible such presents should not be accepted.

2. None of the Fathers or Scholastics living in the town houses may ride the bicycle without leave in writing from the Provincial.

3. Such as get this leave must never ride through the "City" but only in the suburbs or in the country.

4. NO ONE MAY USE THE BICYCLE WHILE GIVING A MISSION OR A RETREAT

5. Long runs or "Record Runs" are not to be allowed, and when any one goes to a considerable distance from his residence he must get permission and have a socius.

6. Ours are strongly recommended not to bicycle near the city without real necessity, and all, both in dress and in every other respect should be mindful of the good name of the Society.

 P.Keating, S.J.

Letter to Fr Rector, 1899

126

makes decisions about the use of money which might have come to him through inheritance or gift. Apart from that, money did not enter into the motivation of individual Jesuits, so that there was no such thing as looking for a rise, or remuneration for work done.

The pinch of poverty was felt not in the lack of wages, but in the small restraints that from time to time Provincials saw fit to impose on their subjects in the name of poverty. The founding fathers had no meal between breakfast at nine and dinner at five, except a *bicchierino* of wine and a piece of bread for lunch, a custom they had brought from their Sicilian training. When the Provincial, in the name of poverty, substituted a 'weak, acidy beer' for the wine, it touched a live enough nerve to spark off letters to the General.[10] Towards the end of the century the Provincial, after visiting Belvedere, would leave detailed instructions on points that he thought needed

10. C. Aylmer to Roothaan (Jesuit General), 12 July 1839. This is one of a set of letters between Irish Jesuits and the General in Rome. hereafter cited as *Roman letters*. The Latin originals are in the archives of the Jesuit Curia in Rome, whence they were kindly culled and photocopied by Fr Bottereau, Jesuit Archivist. They were translated by the author.

correction. In 1895, for instance: 'It would be well to avoid being too frequently seen at football matches and polo matches, especially on Saturday evenings.' And in 1904, when the appearance of the bicycle had confronted superiors with new possibilities and problems: 'Bicycles may not be ridden in or through the city, nor may one ride a considerable distance from home without express permission of the Rector or without a Socius. A soft hat may be used in bicycling or when going with the boys to the football or cricket field; but not on other occasions.'[11]

Over the generations, the second vow, of chastity, has released time, energy and love for the pupils that would otherwise have been given to a wife and family. Many 'fathers' showed a concern for the boys that was, in a real sense, paternal, manly, affectionate and un-possessive. Like the poverty of individual Jesuits, this aspect of celibacy is taken for granted in the daily life of the school, and over the generations it has certainly affected the quality of education in Belvedere.

So has obedience. There is no *cursus honorum* in the Jesuits, no line of offices up which one rises gradually or rapidly, as in a diocese or the civil service — unless one blots one's copybook. It is normal for a Jesuit to spend six years in an office of high responsibility, such as Rector or Provincial, and then revert to the ranks when he has given his best energies. Jesuits can be and are moved from teaching and administrative posts, without any advance warning, by their superiors. This transferability is an act of faith on their part. The discretion invested in religious superiors differs from the freedom of some business executives to hire and fire at will, in that the superior retains responsibility for the alternative employment, and for the apostolic effectiveness and contentment of the Religious who is being moved out of teaching. This sacrifice of freedom on the Jesuit's part is clearly a blessing to the school. Teachers and parents know the harm that can be done to a group of pupils by constant exposure to a teacher who for one reason or another has become lazy, neurotic, incapable of a human relationship with his class, or simply incompetent as a teacher. And as the weak can be moved out, the strong can be moved in: our first Prefect of Studies, Fr John Shine, had established a reputation as teacher and Prefect of Studies in Clongowes before organising the little school in Hardwicke Street. Ever since then, the mobility of Jesuits between schools has in general worked for a better and more contented use of talents.

One obvious effect of this mobility of Jesuits is to discourage ambition. Since authority is seen as a form of service, those who actively seek it are suspect. In 1855 the suspicion of *ambitus* was

11. Visitation Book, Belvedere Archives.

enough to disqualify Fr John Grene from being appointed Rector, although he was already a caretaker Vice-Rector.[12] By contrast the records show some of the most effective Rectors begging the General to move them from the job: Fr Meagher in 1846,[13] Fr O'Ferrall in 1861,[14] Fr Finlay in 1884,[15] and Fr Cullen in 1888[16] all felt unequal to the job, but only O'Ferrall and Cullen were relieved of it.

The most startling effect of the vow of obedience is to be seen in the list of Prefects of Studies and Headmasters from 1832 to 1980;[17]

12. M. O'Ferrall to Beckx, 11 September 1855, Roman letters.
13. P. Meagher to Roothaan, 5 February 1846: 'I am quite unfit for this job. Let a man be appointed who is serious, realistic, learned, carries authority and experience, and is not distracted, as I am, by many other tasks, however good they may be' (Roman letters).
14. M. O'Ferrall to Beckx, 14 May 1861: 'I do not seem to be able to carry through the improvements I see as necessary for the college; so I have decided to ask Your Paternity to let me hand over the care of this college to someone else, who by his own competence and possibly by managing the Provincial better, may promote the fortunes of Belvedere more effectively than I have been able to do' (Roman letters).
15. T. Finlay to Anderledy, 8 January 1884: 'If I may add a word about myself, I would ask your pardon for my many shortcomings. My energies hardly suffice for the tasks imposed on me. Together with the Rector's office I am Professor in the Royal University and Director of the Lyceum Club. What obedience commands, I shall try to perform, but I am well aware how often I fail in these various tasks' (Roman letters).
16. Lambert McKenna S.J., *Life and work of Rev James Aloysius Cullen, S.J.*, London 1924, 192.
17. *Prefects of Studies/Headmasters from 1832 to 1980* (in parentheses is given the age at appointment).

Appointed in		Father
1832	(43)	John Shine; died of cholera in 1834
1837	(53)	Paul Ferley
1840	(39)	Michael Kavanagh
1847	(40)	Patrick Sheehan
1851	(38)	Frank Murphy; also Rector from 1856
1858	(42)	Michael O'Ferrall; also Rector
1864	(41)	Edward Kelly; also Rector
1873	(50)	John Matthews; also Rector
1878	(50)	Tom Kelly; also Rector
1882	(44)	Edward Donovan; also Rector
1883	(36)	Tom Finlay; also Rector
1887	(27)	Martin Maher, scholastic
1889	(35)	Mathew Devitt; also Vice-Rector
1891	(45)	John Conmee
1892	(42)	Thomas Wheeler; also Rector
1894	(36)	William Henry; also Rector
1900	(35)	Patrick McCurtain
1901	(42)	Nicholas Tomkin; also Rector
1907	(37)	Lambert McKenna
1908	(54)	James Brennan; also Rector
1910	(36)	John Fahy; also Rector from 1913
1919	(49)	Lambert McKenna

these were the men who effectively ran the school, and for much of that period the Prefect of Studies was also Rector of the community.[18] Jesuits were put into the job at an age when experience and energy were most effectively balanced, in their thirties or early forties, and were left in it for only a few yars. The average age of men at appointment was just over forty-one; their average term of office was four and a half years. They were not allowed to grow stale on the job.

Belvedere was only one of the schools in the Irish Jesuit Province, itself forming perhaps one hundredth part of the Society of Jesus throughout the world. It is one member of a large family, with all the consequences of mutual support and sibling rivalry that come in such families. Within Ireland the Leinster schools in particular, Clongowes and Gonzaga, have been seen as sisters — one older and one younger — but this did not prevent feelings of jealousy when staff were taken from Belvedere to strengthen the other schools, when Clongowes beat Belvedere in a controversial rugby final,[19] or when children of Old Belvederians were seen wearing the purple or the green. Fr Rupert Coyle, who broke all records by remaining twenty-one years as Belvedere's Prefect of Studies, was said to undergo a sea-change in relationships with old pupils who had sent their children to Gonzaga. He and his predecessors always looked searchingly at the quality of Jesuit teachers distributed between the different colleges. Fr St Leger in 1845 saw Tullabeg as the easiest to please: 'Three

1920	(37)	Michael Quinlan; also Rector from 1922
1926	(40)	Edward F. Ryan
1927	(36)	Tom Counihan
1933	(37)	Rupert Coyle
1954	(46)	Gerard McLaughlin
1960	(45)	Diarmuid Ó Laoire
1962	(50)	John A. Leonard
1968	(48)	Bob McGoran; also Headmaster from 1972
1973	(38)	Noel Barber
1980	(55)	Paddy Crowe

18. *Jesuit titles:* The Society of Jesus is ruled by a General in Rome, directly answerable to the Pope. It is organised into Provinces, each of them ruled by a Provincial. Each house is ruled by a Rector or Superior. He has a Minister to manage the buying and house-keeping for the community. Through the nineteenth century, Belvedere's Rector was generally also Prefect of Studies of the school. With the growing size and complexity of the school, its management was entrusted to a separate Prefect of Studies, or since 1971 to a Headmaster.

19. The 1925 final of the Leinster Schools Senior Rugby Cup, between Clongowes and Belvedere, was the stuff of legend. Clongowes came from behind to win by a converted try in the dying seconds of the game. The Clongownian who scored, the Belvederian who missed the tackle, the referee's watch, which Belvederians claimed was stopped'or slow, all became part of the legend. The ensuing argument was finally laid to rest when Clongowes won the cup again in 1978, and Belvedere joined in their rejoicing with a gift of champagne.

priests are more than enough to staff it, and it serves as a testing-ground where young teachers can display their first fruits before they are sent to Clongowes or to St Francis Xavier's College.'[20] Fr O'Ferrall was more querulous in 1861: 'Two or three new houses have been opened. We are left with the slower teachers, and with men who want to be in Dublin for their own convenience or for private study. The younger and more industrious are sent to other places, such as Limerick.'[21]

The larger family outside Ireland also affected Belvedere. Most of the Jesuits who taught here had studied abroad, whether in the sciences, humanities, philosophy or theology; and memories of Italy, Germany, France, Spain or the Low Countries were an antidote to insularity. Another antidote was correspondence with the General in Rome, which was a strict duty of the Rector and Provincial. General John Roothaan in particular worked hard to restore close links between Rome and the Provinces after the Restoration of the Society, and had no time for Jesuits (like Fr Aylmer) who were too busy to write reports to Rome. 'Woe to those members who act as though they are cut off from their head', he thundered,[22] threatening to land them with an English Provincial if they did not correspond better. As a result the Roman archives hold records of the first thirty years of the College which are considerably better than any records that survived in Ireland. The General made many of the key decisions about the school, such as the choice of Superior; he was concerned, exigent and influential, and one result was that Belvedere survived crises that would have killed a totally independent school.

By the end of 1832, St Francis Xavier's School in Hardwicke Street had fifty-one pupils. The staff consisted of Frs Shine and Robert O'Ferrall, who took time off from priestly duties in the church to teach classes in the school. They would hear confessions for one or more hours on weekdays and all day Saturday. They preached, said public Masses, and were on call for the sick of the neighbourhood.[23] In 1834 the sick included cholera victims. One August day Fr Shine, returning from such a bedside, began to show symptoms of cholera, and was dead within twenty-four hours. Such was the terror of the disease that he was taken that night to Glasnevin Cemetery and

20. R. St Leger to Roothaan, 31 March 1845, Roman letters.
21. M. O'Ferrall to Beckx, 14 May 1861, Roman letters.
22. Roothaan quoted by P. Kenny writing to C. Aylmer, 1 May 1836, Clongowes archives. The post between Dublin and Rome appears to have been regular and improving steadily. In the 1850s the General wrote his answer less than two weeks after the Dublin letter (see note 54 below). In 1888 Fr Finlay thanks the General for letters posted in Rome just three days earlier (letter of 15 July 1888).
23. P. Kenny to Roothaan, 21 June 1839, Roman letters.

buried by torchlight.[24] His companion, Robert O'Ferrall, left in great distress to spend a few days with his father in Ballina, but he too showed symptoms on the journey, and was buried in Mayo the following day. The two-year-old shool had lost its entire staff.

The three priests who took over the school were young, inexperienced and unknown. The letters to and from the General soon showed a severe crisis of confidence. 'That Dublin school was started rather rashly', wrote the Provincial in 1838. 'The site is gloomy and unsuitable, we have not enough experienced teachers, and the men there would rather be working in the church than in classrooms.'[25] The Rector of Tullabeg, the influential Fr John Curtis, agitated in 1835 to get one of the three Hardwicke Street priests onto his staff, and advised that St Francis Xavier's school be suspended or abandoned in order to release the man in question.[26] Even the founder, Fr Aylmer, had doubts: 'Our public school in Dublin is doing badly', he wrote to the General in 1839. 'We have not enough workers to serve both church and school, the school building is wretched, and neither the superior nor the Provincial show much concern about it.'[27]

Had the school been left to its own resources at this point, it might well have closed its doors for good. Instead the problems were solved one by one, at the instigation of the General. A new building was bought for it, Belvedere House, in 1841. The teaching Jesuits were hived off from the Gardiner Street community. They were gradually relieved of their church duties, so that they were able to devote all their energies to their pupils. They were given younger and better-trained teachers. The turning-point came in 1845. In January the Provincial was still doubtful enough about the future of Belvedere to suggest strongly to the General that the building would be better used as a retreat house;[28] but by December the enrolment was up, the community was contented under its new Rector, and Belvedere had achieved an independent and fairly stable existence.[29]

Its stability depended on having pupils, and for a long time enrolments were a worry for Rectors and Provincials. In an age of compulsory school attendance and valuable Leaving Certificates, it is easy to forget how little inducement there was to keep children in school 150 years ago. The first roll-book records the dates of entry and departure of each boy. The average stay of those first pupils was, astonishingly, only ten months. They came and left in every month

24. W. J. Fitzpatrick, *History of the Dublin Catholic Cemeteries*, Dublin 1900, 31-2.
25. J. Bracken to Roothaan, 31 March 1838, Roman letters.
26. P. Kenny to J. Bracken, 21 August 1836, Roman letters.
27. C. Aylmer to Roothaan, 21 July 1839, Roman letters.
28. R. St Leger to Roothaan, 31 January 1845, Roman letters.
29. R. St Leger to Roothaan, 22 December 1845, Roman letters.

COLLEGE OF ST. FRANCIS XAVIER,

Late Belvidere House,

OPENED, 16TH SEPTEMBER, 1841.

The System of Education in this Establishment comprises the full Classical Course, adapted to those who are destined for the Universities or the Learned Professions.

In addition to the Greek and Latin Authors, this system embraces elementary instruction in the various branches of Science and Literature, suited to the exigencies of the present day, and preparatory to subsequent and more extensive acquirements.

During the Classical Course, the Students are regularly exercised in Elocution and Composition, in the different Languages. Special attention is paid to the French, Italian and English Languages; to History, Geography, Use of the Globes, Writing, Arithmetic, Bookkeeping and Mathematics.

Constant care is taken to train the pupils in the precepts and practice of Christian Morality, and at least once each week an instruction is given them on the principles of Religion.

Logic, Metaphysics, Moral and Natural Philosophy follow the Classical Course.

Those who are not intended for the Learned Professions, and do not require the full Classical Course, will have every opportunity of acquiring knowledge in the English, Scientific, and other branches of Education, adapted to the department in life which they mean to embrace.

TERMS:—Classical Course, Twelve Guineas; Philosophy, Sixteen Guineas per Annum, paid quarterly, and in advance.

Music, Drawing, Dancing, Fencing, &c. are Extra Charges.

Application for admission, or for further particulars, to be addressed to the President, the Rev. Robert Haly, at the College, Great Denmark-street, or at the Presbytery, Upper Gardiner-street.

Extract from the
Catholic Registry, 1842

of the year, responding quickly to the quality of teaching and administration. In contrast to today, it was a parents' market, and the little school went to remarkable lengths to accommodate individual needs.[30] Belvedere was an early part of that extraordinary blossoming of Irish Catholic schooling which filled the nineteenth century; and it aimed at a specific segment of the market, which it defined by its neighbourhood, its curriculum, and its fees.

The segment comprised what the Latin letters called *honestae familiae,* middle-class families, relatively well-to-do, and aspiring — after Catholic Emancipation — to take an increasingly active part in the public life of Dublin and Ireland. Fr Bracken wrote in 1838[31] of the need to wean Catholic families from their tendency to send their children to school in England or to Protestant schools in Ireland. Nine years later the Rector, Fr Patrick Meagher, reported the first signs of success.[32] The school had held its first public academic ex-

30. Roll-books up to 1890 repeatedly mention special dispensations for individual pupils, such as, 'To be taught English and German only'; 'Protestant: not to attend Mass or learn catechism'; 'Latin and Greek Verse and Prose, organ, band, drawing, painting'.
31. J. Bracken to Roothaan, 28 February 1838, Roman letters.
32. P. Meagher to Roothaan, 30 January 1847, Roman letters.

133

amination[33] just before Christmas, a display, before parents and public figures, of all that the boys had learned; a genteel form of advertising in the days before PROs or school annuals or the publication of examination results. 'It was a success far beyond our hopes', wrote Fr Meagher. 'The parents and all the others were delighted. In the course of the examination the Archbishop of Dublin (a man outstanding for piety and learning) said to a nobleman sitting beside him how absurd it was for parents to send their son to be educated abroad, far from home, when such an education as this could be found at home. We have been flooded with sincere and repeated congratulations.'[34]

As you read the Rector's self-congratulatory comments, is there an ugly word sounding at the back of your mind? Snobbery, meaning an exaggerated respect for social position or rank. In fact, as the story on page 33 illustrates, Fr Meagher had no illusions about human vanities. Part of his brief was to substitute something authentic and Dublin for what many families were seeking abroad. His colleague Paul Ferley had written to Rome in 1841: 'The children of the rich are practically all educated now in non-Catholic schools, to the great sorrow of the Archbishop, the clergy and all good men. They want to see a college opened which will meet the expectations of our citizens, and entice the sons of the rich back from the non-Catholic schools, where their morals now stand in great danger and their faith is sometimes lost.'[35]

The fees in Belvedere were two guineas a term from the start, and they hardly changed through the rest of the century: high enough by comparison with other Catholic schools, which like Belvedere were almost all subsidised by a religious community. Before the Suppression, Jesuit schools had regularly been endowed by a patron, and charged no fees. It was contrary to Jesuit tradition to establish a financial criterion for acceptance into a school. The tradition depended on patronage and endowment, which was no longer practicable in nineteenth-century Dublin. In 1833 Fr Roothaan had formally dispensed Irish and English schools from the veto on charging fees;[36] until 1878 there was no other source of finance for the school. The

33. *The Belvederian*, vol.11, no.2, 1937, recalls scientific experiments and scenes from Shakespeare as typical items in such an examination. Fr Grene in his journal recalls more pretentious items from his days in Clongowes: a recital of Cicero's *Pro Milone*, translated into Greek by a boy from Rhetoric; and a disputation in French between teachers of Fencing, Music and Drawing, each arguing the case for his subject. Fr Grene, 'Journal', manuscript in Jesuit archives, Leeson Street.
34. P. Meagher to Roothaan, 30 January 1847, Roman letters.
35. P. Ferley to Roothaan, 31 March 1841, Roman letters.
36. J. Roothaan to English and Irish Provincials, 1 February 1833, Leeson Street archives.

income from them was tenuous, and sensitive to every swing in the school's reputation. Even so, fees were charged reluctantly, and with a degree of scruple and guilt. The first conspectus (see the notice in the *Irish Catholic Directory* for 1838) mentioned no specific fee, but 'for terms apply to the Rev. Charles Aylmer or to any of the Rev. Gentlemen'. There was considerable scope for negotiation. The fee-books show a range of figures charged, depending on the family's circumstances. In one well-researched class,[37] that of James Joyce in 1893, only twenty-one of the twenty-eight boys paid fees, and of these only twelve paid the full amount, £3 a term (the Joyces, like many others, were 'free boys' throughout their time in Belvedere). Bereavements or bankruptcies regularly meant remission of all or part of the fee. Apart from remissions there were numerous bad debts on a scale far larger than would be found in a business. School fees, like doctors' bills, easily find their way to the bottom of a hard-pressed family's financial anxieties, and this was — and is — particularly likely where the father is trying to maintain a flamboyant style of living for the sake of his business or public persona; he has calculated the menace of his various creditors, and knows that schools are most unlikely to use the law on him.

The history of fee-paying would make a chapter in itself, reflecting the, to us, strange phenomenon of deflation in the last third of the nineteenth century,[38] so that the full fee fell from £10 per annum in 1852 to £8 in 1879, and was still only £9 in 1906, with remissions more numerous than full payments. It rose steadily to £79 per annum in 1971, and then rapidly to £315 in 1980—81, reflecting the inflation of the economy, a growing realisation of the actual cost of running and maintaining the school, the improved level of facilities and buildings, and the greater involvement of salaried (and more adequately salaried) laymen in place of unsalaried Jesuits in the curricular and extra-curricular life of the school.

When the government in 1966 offered to pay a grant of £25 per annum in lieu of fees, Jesuit schools considered the option carefully and in detail. Two of the four day-schools, those in Limerick and Galway, took a cut in their income of about 20 per cent and entered the 'free scheme'. Belvedere's fees stood at £69 per annum that year. To drop from this to £25 per boy would have meant a cut in staffing and facilities (library, games, opera, and other extra-curriculars) that would have transformed the school's character. The option was considered carefully, but not chosen. Since then Belvedere has worked to maintain and improve its facilities and the education it offers, and charge fees which will make that possible; in terms of

37. Bruce Bradley S.J., *James Joyce's schooldays*, Dublin 1982, ch.2, *passim*.
38. The cost of living, as measured by the British Board of Trade Wholesale Price Indicator, dropped from 140 in 1870 to 100 in 1900.

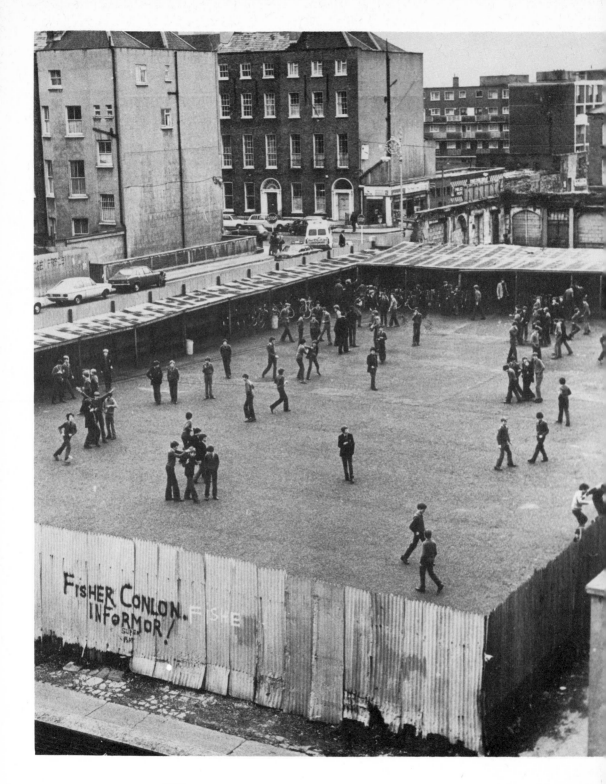

138

expensiveness it stands in the bottom half of fee-paying schools.

This choice was not made without anguish and backward glances. The Jesuits serving Gardiner Street parish remark that few of their parishioners attend Belvedere; many of them could not afford it. In recent years the Belvedere community has included Jesuits working with young people in Summerhill and Ballymun; they see the sharp contrast between the deprivations of their charges and the opportunities open to the pupils of Belvedere. Our colleagues in Limerick serve a comprehensive school which meets the diverse needs of the bright and the dull, the affluent and the deprived. Ever since the decision of 1967 to remain fee-paying and academically selective, the option of 'going comprehensive' has occasionally been dangled in front of Belvedere, but again rejected. There is no local demand for that — in fact such a move would threaten the neighbouring vocational school with which Belvedere has always shared facilities and often staff. There is an insistent demand for Belvedere as it is, a demand expressed in the ratio of four or five applicants for every place that falls free in the school. The parents are identified less by their income than by their educational and religious aspirations, their readiness to budget generously for a schooling that is religious, rich in what it offers, and exigent in what it demands.

In the early days the location of the school helped determine its clientele, and that location was partly accident, partly deliberate choice. The Jesuits were invited into Hardwicke Street because the increase in traffic — the street was being developed as a grand avenue to St George's Church, Temple Street — rendered it unsuitable for the contemplative life of the Poor Clare Convent then occupying the building. The Jesuits used it as a chapel from 1816, and as a school from 1832, but it was never attractive or suitable. Two major decisions were taken in 1839—40, both heavy with the might-have-beens of Belvedere's history. At a time when the Provincial needed little urging to close down the infant school, he received an offer through Archbishop Daniel Murray which he mentioned later, and casually, to the General.[39] 'There is something I forget to mention in my last letter to Your Paternity. In July the Archbishop told Fr Kenny that the Congregation of St Vincent de Paul (the Vincentians), which has a pretty large school in this city college wished to hand it over to us, or else give it up altogether, because they wished to devote themselves exclusively to the giving of missions. An answer had to be given quickly, so I called together my Consultros, we considered the matter seriously, and decided unanimously against accepting that school — for a number of reasons, but, particularly . . .' and here the next page of manuscript has tantalisingly been lost. The

39. J. Bracken to Roothaan, 31 August 1839, Roman letters.

May.
1892

31	Mr Foy tutor	10	" "
"	Mr Dempsey "	12	" "
"	Mr McCluskey "	7	" "
"	Mr Ryan	6	" "
31	Brannan &c for wine + whiskey	15 8 6	
"	Monthly Bill	26 3 1	

Victus

Butcher	4 months	104 - 0 - 0
Milk	2 months	6 - 15 - 8
		110 - 15 - 8
Devin Baker		2 . 16 . 3
Kenna Butter		4 . 17 . 4
Hanlon Fish &c		4 . 3 . 1
Madigan grocer		5 . 5 . 0
Mullen veg.		2 . 16 . 9
Fleet Fowl		2 . 7 . 3
Leigh Brown &c		1 . 17 . 8
Apples		1 . 15 . 0
Suet		4 . 9
		26 . 3 . 1
		£136 18 . 9

Excerpt from College
Day Book, 1861–97

school on offer was at Usher's Quay, where it was served by the
Vincentians from Castleknock; it was the first time that St Francis
Xavier's College was tempted to cross the Liffey to the south side.

In the following year, 1840, the money accruing to the Province
from Fr Charles Young's renunciation gave the Jesuits the opportunity
they wanted, to move the school out of Hardwicke Street. Two
houses were on the market, and within their means: Antrim House,
now the National Maternity Hospital, Holles Street, and Belvedere
House on Great Denmark Street. Father Richard Campbell, who
entered Belvedere twenty years later, reconstructed the reasoning of

140

1840: 'The north side of the Liffey was then the important part of the city, and therefore Belvedere was selected'.[40] The decision to over-look Mountjoy rather than Merrion Square was momentous. The doors of Belvedere House opened to a new set of scholars on 16 September 1841, most of them drawn from within walking distance.[41] Before the development of public transport the school drew mainly from its neighbourhood, and so it remained until the middle 1880s when the outstanding Rector of the century, Fr Tom Finlay, took office. In his first letter to Rome, after explaining his building plans, he added: 'I saw that parents who live in more distant parts of the city are un-willing to send their sons to our college — a long walk through the public streets; so I decided to acquire coaches by which the boys might be driven to and from school in the care of College staff. £150 were needed to launch the operation, but the number of boys using the coaches is expanding. Each of them pays £6 a year in addition to the fees, so the college will soon recoup its outlay on the coaches.'[42]

It was the first move to make Belvedere what it has since become, a central school drawing from the whole city — in recent times from the whole county. A list of addresses from the 1980 College roll-book[43] shows this vividly, and recalls the only recent attempt to reverse the trend. The Belvedere House site had been expanded by three building programmes, Fr Finlay's in the 1880s, Fr Quinlan's in the 1920s, and Fr Roche's in the 1950s. Before the latest buildings were planned, in the late 1960s, it was seriously proposed to move the school to Cabra, and rebuild it beside its fine playing fields there. It would have turned from a central to a local school, and despite the drawbacks and constraints of the old site, the Jesuits opted to stay there and draw from the whole of Dublin.

The teachers who started the school in Hardwicke Street were burdened with a tradition which was in part mythology. The Jesuit

40. *The Belvederian*, vol.11, no.2, 1937, 9.
41. Belvedere House was a bargain, with a history. In 1786 Lord Belvedere had spent £24,000 on its construction and decoration, in a street where every second residence housed a title. Lord Belvedere started as a cham-pion of Grattan and the Irish Parliament; he and his henchmen vehemently denounced the proposals for the Union of Britain and Ireland. Lord Castlereagh, however, scattering money and titles to secure votes for the Union, sensed that Lord Belvedere did protest too much; he was worthy of temptation. Castlereagh's agents sounded his sympathies and made him an offer he did not refuse: £15,000 to support the Union and another £10,000 as *douceur*. The turncoat lived to see the consequences. His titled neighbours slipped away gradually to London; trade and the value of property declined; and despite two marriages he died without issue in 1811, the last Earl of Belvedere. Thirty years later, deserted and in disrepair, Belvedere House passed to the Jesuits for £1,800.
42. T. Finlay to Anderledy, 8 January 1884, Roman letters.
43. *The Belvederian*, vol.26, no.1, 1980, 41.

system for organising studies, the *Ratio Studiorum,* was quoted with respect by many who had never read it. All through Belvedere's history, but especially in the early years, one senses a conflict between the rhetoric of the tradition and the reality of the classroom. The strength of the *Ratio* lay not in what was taught — that was shared with other grammar schools — but in some principles which have been absorbed into European education to the point where they seem obvious and even banal:

(*a*) A solid foundation must be laid in grammar before passing on to the reading of authors.

(*b*) The student is not to move on to a higher branch before he has mastered the lower.

(*c*) The students should be graded in classes according to their attainment, and progress to a higher class should be through examination.

(*d*) Regular attendance should be compulsory.

Apart from the first of these, which refers to the study of classical languages, the principles would help the learning of anything from sums to sailing, from geography to golf. In Jesuit schools the method was applied to an ordered sequence of disciplines: first language and literature, then philosophy and natural science, and finally theology. Father General Roothaan produced a revised *Ratio* in 1832, and circulated it to all the Provinces to be tried out, criticised, corrected and finally given 'the force and sanction of a universal law'. Although it made room for Shakespeare and Racine, and urged teachers to keep up with developments in their subjects, the document could not cope with the diversity of educational systems and the explosion of knowledge. It was rapidly superseded and never became an effective guideline for schools. Not even for Belvedere. In January 1847 the Rector, Fr Meagher, wrote in obvious embarrassment to Roothaan: 'Your Paternity's recommendation, that we plan our curriculum to produce learned men rather than merchants, will receive due consideration. ... We wanted to start a new programme of studies in every class at the beginning of this year. Some years ago Your Paternity kindly sent the Vice-Province two copies of the *Ratio Studiorum.* We have looked for them everywhere, but neither copy could be found. . . .'[44]

Fr Meagher had spent seven years in an English boarding-school on an unrelieved diet of Latin and Greek, and he deplored it. 'Bacon's praise of Jesuit schools no longer holds true today. Our system is spoken of by our friends with sorrow, by our enemies with contempt. Parents ask us to prepare their boy for such-and-such a career, but care nothing for Latin and Greek "He doesn't need them", they

44. P. Meagher to Roothaan, 30 January 1847, Roman letters.

say, "I'd rather his time and intelligence were devoted to the 'accidentals'" [modern languages, maths and science were called *accidentalia* in the *Ratio Studiorum*; they were seen as marginal to the classical core of the curriculum]. Even at a time of prosperity a Rector who persisted with the old system would quickly be forced to close down school. But in this climate of universal misery and calamity [the year was 1847], where a quarter of our people are dying of famine, and another quarter forced to emigrate, parents choose an education not to make learned men of their sons, but to fit them to earn a living."[45]

For over forty years Belvedere had no Irish norms to follow in planning its curriculum, and worked in this tension between the classical model of the cultivated European and the pragmatic requirements of parents. Fr Sheehan, who as Prefect of Studies, worked in happy partnership with Fr Meagher, outlined the 1847 programme:

Elements how to write, read and do simple sums.
III Grammar Latin grammar and sentences. English grammar.
II Grammar Caesar. Latin and Greek grammar.
I Grammar Greek New Testament. Sallust.
Humanities Homer, Virgil, Cicero, Lucan.

'All do a daily composition in Latin or Greek or English. The morning is given to Latin and Greek, the afternoon (12 to 2.40) to English, French, Maths and all that the *Ratio* calls *accidentals*. These are considered very important by our parents, and unless they are well taught, the school will decline.'[46]

A decade later Rector Michael O'Ferrall was stressing the same: 'Our parents want maths, modern history, geography, French and the rudiments of Latin. They are not worried about progress in literature or in what they call the dead languages. . . . They set great store by those arts which will fit their sons for jobs in the city.'[47]

For forty-six years Belvedere enjoyed the freedom to plan its own curriculum, an uneasy freedom, pulled in one direction by what the Jesuits understood as the tradition of the *Ratio* and in another by the insistent requests of parents. When, in 1878, the school was offered the constraints and rewards of the Intermediate Examination System, it seems to have jettisoned its freedom unhesitatingly. From 1878 to the present day the curriculum has been shaped by central bodies, first the Intermediate Education Board, and after 1924 by the Department of Education. The Intermediate Board gave grants to schools in proportion to their results in the public examinations.[48]

45. P. Meagher to Roothaan, 5 May 1847, Roman letters.
46. P. Sheehan to Roothaan, 6 May 1847, Roman letters.
47. M. O'Ferrall to Beckx, 3 December 1858, Roman letters.
48. After administrative expenses and individual prizes had been accounted for, the funds available for grants to all Irish schools amounted to between £12,000 and £15,000 per annum. See T. J. McElligott, *Secondary Education in Ireland 1870–1921*, Dublin 1981, ch.4.

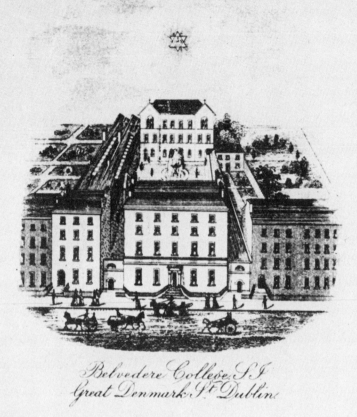

Belvedere College, S.J.
Great Denmark St. Dublin.

ELVEDERE COLLEGE, Great Denmark Street, is conducted by the Fathers of the Society of Jesus. . To parents resident in or near the City of Dublin, who desire to combine in the education of their sons the discipline and teaching of a public school with the very important influences of home life, it offers the advantages of a High Class Grammar School.

The Course of Education comprises the usual Grammar School subjects. In the three Higher Forms boys are prepared for the Intermediate Examinations. Candidates are also prepared for the Entrance Examinations of the College of Surgeons, for Civil Service Examinations, Preliminary Examinations for Solicitors' Apprentices, &c

The School Year is divided into three Terms: First Term, from August till December; Second Term, from December till April; Third Term, from April till July. The Pension for each of these Terms is £3, payable in advance, within the first month of the Term.

Patrick Pearse castigated the system of payment by results, in *The Murder Machine,* but the record shows that its first effect on Belvedere was salutary. Fr Tom Finlay summarised its effects:[49] a clearer shape and direction to the curriculum, and the possibility of repaying the interest on building debts. In a letter to the General in 1884 he had spoken glowingly of the new system: 'In order to promote the pupils' studies and especially to prepare well those who have to sit public examinations, I thought it would be useful to hold a Saturday exam to test the week's lessons, as they do in our Paris college. We have seen results already. Both teachers and boys show tremendous enthusiasm and really hard work. Unfortunately most of the pupils are young, and are in elementary classes. Our only hope of making a name for ourselves is to hold on to the pupils now in the Prep School for another three or four years. That will not be easy. Practically all our boys move out as soon as they reach their fourteenth or fifteenth birthday, either to a boarding school or into a job in the city. In my judgement we shall not achieve our objective unless our teaching is so good that parents realise that their sons will get a better education here than in any boarding school.'[50]

Fr Finlay served for thirty years on the Intermediate Board and was its last chairman, so he lived to see his objective attained by Belvedere. By the mid-1890s it was no longer merely the elementary school which it had been for most of the century. James Joyce and his contemporaries were winning exhibitions at senior level, and the autumn cheque[51] on the basis of results fees became an important entry in the bursar's ledger. The Rector's letters to Rome from 1894 on[52] are brief summaries of the year's work in Belvedere, and the central fact given, as the significant criterion of the school's success, was its performance in public exams. No longer do parents complain about *accidentalia* being neglected; at each age-group from preparatory to senior grade they look simply for results, as measured by the examiners.

The impact of this system on teaching is illustrated in the Inspec-

49. *The Belvederian,* vol.9, no.1, 1930, 4.
50. T. Finlay to Anderledy, 8 January 1884, Roman letters.
51. The income from results fees appears to have fluctuated considerably, from a low of £143 in 1885 to a peak of £686. 9s. 9d. in 1895, with somewhat lower figures after 1900: low enough to draw a comment from the Provincial in his 1903 Visitation.
52. See. for instance, W. Henry to Martin, 26 October 1895: 'I am delighted to tell Your Paternity that we have done much better in public exams from a financial point of view. We received practically £700 by which we hope to reduce the big building debt we contracted...' Also, W. Henry to Martin, 9 October 1897: 'In the public exams this year we did not do so well as regards exhibitions, but financially we fared far better...' The exhibitions won by individual scholars brought credit to the school; but the income for the school came from the passes and distinctions of the ordinary scholars.

tors' Reports of 1909. The inspectors employed by the Intermediate Board that year left a detailed report on the classes they visited. Their general comments on Belvedere were laudatory, but they were critical of Mr Leahy's 'traditional' approach to the teaching of French: 'Grammar, instead of being studied with reference to language material, was taught as a thing apart. The result was that the pupils were unable to understand or express the simplest thought in French. The aim of the teacher was, as he himself confessed, to obtain good results in the intermediate examinations, and anything that did not conduce to this end — such as pronunciation and easy conversation — could afford to take a subordinate place. The teacher had spent some time in France many years ago; he would do well to go again and attend some practical classes in French phonetics.'[53]

We know from other sources that the inspectors' judgment could be seriously mistaken. The same Mr Rea who criticised Mr Leahy said of George Dempsey's English class: 'As in Modern Language the real needs of the pupil are sacrificed to the necessities of the examination.' In fact critical pupils like Joyce and Arthur Cox testify that Dempsey opened the minds of a whole generation to the wider pastures of literature and history; he was by any standards a superb and imaginative teacher. It may well be that he put on an examination-oriented act on the day of inspection, misreading the bias of his visitor. However the quoted comments of Mr Leahy give evidence of the dominance of the examination over the matter and method of teaching.

Unlike its younger sister Gonzaga, Belvedere has never tried to shake off the controlling influence of public examinations, which has, if anything, increased with the generations. Payment by results ended with the establishment of our own Department of Education, but the Leaving and Intermediate Certificates replaced the senior and junior grades, and in recent years many fourth-year boys take GCE 'O' level exams as well. It was a sign both of the educational diffidence and the financial straits of the school that it was open to academic sponsorship through much of the nineteenth century. In 1857 the Rector, Fr Frank Murphy, proposed aggregation to the Catholic University, with a view to attracting more students; but the General, fearful of surrendering autonomy, discouraged him.[54] Autonomy was cheerfully surrendered in 1878, to the Intermediate Board; and in addition Belvedere had a brief flirtation with the South Kensington Science and Art Department, which sponsored courses and examinations for a number of Irish schools. Sponsorship required that at least thirteen hours a week be spent on science and mathe-

53. Intermediate Education Board for Ireland, *Reports of Inspectors 1909-10*, vol.1, no.58, Dublin 1910.
54. F. Murphy to Beckx, 31 January 1857; Beckx to F. Murphy, 12 February 1857, Roman letters.

matics. In a school already geared to the Intermediate Examinations at preparatory, junior, middle and senior levels, this additional constraint must have considerably complicated the work of the Prefect of Studies. But it was done, 113 boys being entered for the South Kensington exams in 1894, and in consequence a claim was entered for £52.10s.0d. Presumably the rewards were found to be inadequate, for the Science School ledger closes at this point. In 1902 the sciences were lifted to equal status with the classics and languages in the Intermediate Board examinations. The Belvedere staff had always shown an enthusiasm for the sciences, sometimes tinged with guilt because they were *accidentalia* in the *Ratio*. In the 1840s Fr Meagher had been criticised for preferring experimental philosophy and chemistry to the classics.[55] In the 1850s Fr Grene left the school £20 a year for 'philosophical instruments',[56] which were remembered with affection by William Martin Murphy in 1909.[57] Through the late nineteenth century and since, the science department grew stronger and stronger. In spite of the withdrawal of university support, Latin and Greek survived perhaps better in Belvedere than in most Irish schools; but in the last two decades the greatest strengths of an extremely strong staff have been in mathematics and the sciences. The results are seen in a strong Belvederian representation in scientific faculties of our universities and colleges, and in the occupations where science is used.

It would be gratifying to be able to point to a coherent educational philosophy running through these 150 years, but one may not go beyond the evidence. Religious philosophy there was indeed, a deep and urgent desire to bring boys and families closer to their God through Christ their brother. In curricular matters there is no such clear thread, beyond perhaps a typically Ignatian empiricism, a philosophy of reflecting on and learning from one's own experience. There was a tension between a classical tradition on the one hand, and on the other a pragmatic awareness of the demands of parents, the requirements of employers, and the economics and vagaries of the Irish educational system. Out of this tension came a number of short-lived experiments, which today have a period interest.

In 1904 a physical measurement book, with an army flavour, was started; it registered the dimensions of each pupil at six different points of the body, and was intended to register also his increase since the last measurement. It also noted whether he was 'pigeon-breasted, alar-shouldered, lacking in vital capacity, generally delicate, suffering from curvature of the spine, or from cardiac weakness'; abbreviations were devised for each of these conditions, with a view to remedial drill, or dispensation from drill. One of those so dispensed

55. R. St Leger to Roothaan, 29 May 1846, Roman letters.
56. Fr Grene's Journal (no pagination), Leeson Street archives.
57. *The Belvederian*, vol.2, no.1, 1909, 36.

was a Master Rupert Coyle, on the grounds of cardiac weakness; his heart did indeed fail him in the end, but not before it had pumped blood through his large rubicund frame for eighty-two years, fifty-five of them in Belvedere. The measurement book was discontinued in the year it started: keeping it up to date would have left time for little else.

One year before the Intermediate inspectors castigated Mr Leahy for ignoring French pronunciation, the College entered an arrangement with the École Berlitz, to have a native speaker instruct the Junior boys in his language.[58] He does not seem to have lasted the year. The Professional-Commercial Department, begun in 1929, had similarly disappeared by 1931.[59] Strong national feeling, laced with the lure of government grants, led to the use of Irish as the medium of instruction in some classes in the 1940s; some of our most public figures today remember being taught Greek through Irish by Fr Barney Collins, who went on to teach the Tonga language to fellow-Europeans in the south of Zambia. In the 1960s, when we used to say the pessimists were learning Chinese, Belvedere optimistically launched classes in Russian; but again the market folded.

The school's concern for public speaking, games, music and art was more durable. Professor Bell, author of *Bell's Speaker*, was one of the great figures of the nineteenth-century staff. His subject, elocution, was a casualty of the Intermediate system, but it rose to a vigorous and sustained life in the debating and dramatic societies of the present century. The college can claim no credit for the extraordinary talents the Lord has from time to time landed on our doorstep, figures like Gerard Victory and John O'Connor in music, Harry Clarke, Fr Jack Hanlon and Leo Whelan in the visual arts, Joyce in prose, the Quinns in sport, Gary Trimble in sculpture and Tony O'Reilly in industrial management. Some Jesuit decisions, however, did help these talents to flower. Belvedere was always willing to spend money to maintain a good sports ground: first at Finglas, then Cherrymount (off North Circular Road), Croydon Park in Fairview, Palmerston Park, Jones's Road in 1910, Cabra in 1934, and Anglesea Road in 1948.

The school's investment in music and art was smaller but substantial. The opera, generally Gilbert and Sullivan, has been a feature of the calendar for the last fifty years. The teaching of art has come a long way since the drawing classes of Victorian times: the media have multiplied to include not merely drawing and painting, but photography, and since 1970 a department of Design Technology, where boys learn to work with metals and plastics in addition to the traditional media.

58. *The Belvederian*, vol.1, no.3, 1908, 98.
59. *The Belvederian*, vol.9, no.1, 1930, 85.

The Belvedere staff from the beginning has been partly Jesuit, partly lay, a generally cordial partnership that has shown change and development. In the early years 'partnership' would hardly define the relationship. The Jesuits were the stable core of the staff, and for most of the nineteenth century were better qualified than their lay colleagues. Irish secondary teachers had no system of registration, no recognised or minimum qualifications for the job, no status, no security of tenure, and a pitiful level of pay. A Jesuit now in Belvedere, Fr Peter Sexton, has charted the gradual rise of lay teachers to professional standing, through forming an association in 1909, achieving recognised qualifications and a register in 1919, and later security of tenure, a pension scheme, and a framework for promotion and responsibility.[60] At first they were employed in Belvedere with reluctance. Fr Bracken in 1838 explained to the General: 'At the beginning there were only two Jesuit teachers in the school (Hardwicke Street), and they were caught up in other ministries; so it was necessary to hire lay masters. Some people interpreted this unkindly, saying that the Jesuits, like others, had opened their school only to make a profit.'[61] Such criticism implies that lay teachers somehow dilute the advertised quality of a Jesuit school. However painful the memory, it is worth clarifying such attitudes. Fr Meagher, writing in 1847, was equally apologetic about employing a teacher, but with an additional reason: 'Your Paternity has asked about the employment of a heretic as a teacher here. He was taken on because of the extreme difficulty of finding a suitable Catholic, and because of his excellence as a teacher. He taught Latin and Greek for two hours every morning. The Prefect of Studies or I myself was with him almost all the time. He was employed in a temporary capacity and let go as soon as possible. A Catholic has taken his place now.'[62]

By the end of the century attitudes had changed. Teachers like George Dempsey had served as long and taught as well as any Jesuit. Dempsey earned £124 per annum, at a time when the average wage of a lay teacher in Ireland was £80 for men, £40 for women.[63] Fr Wheeler, Rector in 1893, thought the money well spent: 'Our financial burden is growing because we need several lay teachers for the school; some of our own fathers on the staff are simply neither suitable nor skilled enough for school work, because of weak health or for other reasons.'[64] After 1900, with the increasing availability

60. Peter Sexton, 'The lay teachers' struggle for status in Catholic secondary schools in Ireland between 1878 and 1937', M.Ed. dissertation, University of Birmingham 1972.
61. J. Bracken to Roothaan, 31 March 1858, Roman letters.
62. P. Meagher to Roothaan, 3 May 1847, Roman letters.
63. Peter Sexton, op. cit., 44. The average teacher's salary c.1905 was £82. 6s. 7d. for men; £48. 2s. 7d. for women.
64. T. Wheeler to Martin, 1 February 1893, Roman letters.

of professional qualifications, both the quality and the number of lay staff grew. They outnumbered Jesuit staff in 1905, were one-third of the staff in 1940, and in recent years, with the expansion of school, constitute nearly three-quarters of the staff. The oldest of them can still remember a time when the parting from the Prefect of Studies at the end of the summer term brought with it either the renewal or the termination of his year-by-year contract. By that stage, however, the Prefect of Studies had come to rely on his lay staff as the staple core, who could not be moved by the Jesuit Provincial as his priests and scholastics could. In recent times, for better or worse, it is only the Jesuits who are insecure.

The changes have gone far beyond improved working conditions for lay staff. They now share responsibility throughout the school, in areas which until 1970 were Jesuit. Laymen have responsibility for games, for the opera, and other activities and clubs; there are lay principals of the senior and junior schools, under a Jesuit headmaster. Beyond the sharing of work there is also some sharing in the sense of teaching as a Christian vocation. For both Jesuit and lay the teaching life is a way to God; it fulfils and frustrates, rewards and purifies. The contributions of Jesuit and lay teachers are different and complementary, and the removal of either would impoverish the education in Belvedere. The school is a community of faith, and staff gatherings have focused on this as well as on the endless technicalities of running a school. The last ten years have seen a process of development which is often painful and tedious, because it touches old attitudes and structures, but is full of promise for the future vitality of Belvedere.

Less noticeable, but no less deliberate, is the change of relationship to parents. In the smaller school of the nineteenth century, with enrolments unstable and a steady flow of fourteen-year-olds leaving Belvedere for Clongowes and other boarding-schools,[65] the school showed extreme sensitivity to the wishes of parents, and catered for individual needs in curriculum and in the provision of special transport.[66] The expanded Belvedere after 1900, operating

65. See T. Finlay's letter of 8 January 1884 cited on page 147: 'Practically all our boys move out as soon as they reach their 14th or 15th birthday, either to a boarding school or into a job in the city.' See also Fr Thomas Kelly's obituary in *Memorials of the Irish Province*, 127: 'It was one of his proudest boasts that he was one of the first group of boys who entered within its [Belvedere's] walls on the day upon which it was first opened to the Catholic youth of Dublin. From Belvedere College to Clongowes Wood College was an easy and most natural transition in the life of a Jesuit pupil in those early days, and it was accordingly at this last-named famous seat of learning that Thomas Kelly finished his schoolboy career.' Thomas Kelly entered Belvedere in September 1841, aged twelve, and left for Clongowes three years later.

66. See note 30 above. The roll-books from 1884 on indicate those boys who

under a public exam system, became more exigent in dealing with parents. For nearly three decades of this century the Prefect of Studies left almost all negotiation with parents to the Rector, who had more time to talk, but less knowledge of the boys. A new phase began with Fr McGoran in the late 1960s, in the wake of Vatican II. The language and emphasis was changing in religious education, and it was more than ever necessary to ensure mutual understanding between educators in the family and the school on the deepest human problems and attitudes. The headmaster set himself to be accessible and accountable to parents. It was a deliberate decision, and a costly one in time; but it is being maintained.

One other initiative must be mentioned: to found a union of past pupils. Apart from its large landmarks — the rugby club based on Anglesea Road, the cricket club based on Cabra, the musical and dramatic society which had a brilliant blossoming in the 1930s, and the Youth Club (once the Newsboys), the union has had an astonishing, if quiet, vitality. Outsiders see it as a Dublin Mafia, 5,000 strong, invisible except to one another. Certainly Old Belvederians have a sense of *omertà*, both to one another and to the college, that has few parallels.

When schoolmasters live together, they develop a corporate character with a distinct flavour. What is the flavour of Belvedere, as experienced by those who live here? Someone has divided mankind into warm fuzzies and cold pricklies. The Belvedere charism seems cold prickly rather than warm fuzzy; competitive rather than cosy; hard-working, outspoken, with room for eccentrics provided they work; in its pieties, primitive and without show. (One of our nineteenth-century heroes and longest-serving Jesuits was Brother George Sillery, who at the age of eighty-four interrupted an extended sermon with a loud: 'Mother of God will he ever stop?') Belvederians prefer a school run on a tight rein — 900 boys round a small court-yard requires that — but the style of discipline has varied over the generations. Fr Meagher reported in 1847: 'Our seventy-two pupils are pious, docile, likeable. . . . Never is the least corporal punishment inflicted.'[67] The provincial on his 1852 Visitation was probably listening to the hawks when he commented: 'As there must be many children more or less indolent, the stimulus of punishment is ever indispensable.'[68] In 1859 his successor had to admonish the teachers to avoid slapping, pulling hair and ears, and verbal abuse. A harsher period followed, which Dr Edward Byrne, later Archbishop of Dublin, remembered with some resentment.[69] Fr Knowles,

are to be brought from and delivered to their homes by the school's coaches.
67. P. Meagher to Roothaan, 30 January 1847, Roman letters.
68. Visitation book, 1852.
69. *The Belvederian*, vol.12, no.2, 1940, 28.

156

remembering the school of 1873, writes: 'I bore many a caning and confinement.'[70] The stimulus of the public exams seems to have reduced the need for physical sanctions. In 1901 Fr Tomkin did away with corporal punishment.[71] It returned, however, its use always confined to one or two officials. Fr Coyle, who ran the school longer than any other, was known to dislike using the strap, a gently reassuring knowledge for the condemned. In the last ten years, factually though not formally, corporal punishment has almost disappeared.

In spite of this recurrent hawkishness, and the expanded size of the school, it is a place where bonds are formed, both within and between the generations. The yard has always been something of a forum for meetings of teachers and boys. Mr Fogarty was astonished, when he arrived here to teach French in 1909, by the directness and ease of relationships, and in that respect the yard has not changed. It has seen anger and hurt, healing and happiness, scenes of triumph over trophies won, of congratulations at jubilees and successes, planning of debates and projects, plotting of mischief, all against the unchanging sound of boys at play. Compared with Fr Meagher's time the boys are twelve times as numerous, equally amiable, but probably less pious and less docile. Compared with Fr Meagher's, the present Jesuit community is five times as large and quite diverse. It is a centrifugal community, its members constantly drawn out to work in the city. Some give their whole time to the school and its extra-curricular activities. Others spend much of their evenings and weekends on priestly work in the neighbourhood and further afield. The Belvedere Youth Club, the Fr Scully Flats for old people, and four conferences of St Vincent de Paul, are results of such part-time work by Belvedere teachers.

The scene is healthy now, beyond the expectations of Fr Bracken when in 1840 he wrote: 'We have acquired a large, beautiful house on a splendid site, such as may be worthy eventually to deserve the title of a college, provided we can find the men for it.[72] It has come through crises since Fr Bracken's time, the last of them in 1971, when the Jesuit Provincial saw that he would not have enough men to run six colleges in the future. He set up a commission of three men to look hard at each of the six colleges, and recommend one of them for closure. (The two Jesuit inquisitors were quickly dubbed Cranmer and Cromwell, the men Henry VIII sent out to suppress the monasteries.) From that close scrutiny of every facet of the schools, Belvedere emerged with distinction. It was spared and Mungret was closed, a boarding school more demanding of Jesuit manpower.

70. *The Belvederian*, vol.8, no.1, 1927, 100.
71. *The Belvederian*, vol.13, no.2, 1943, 40.
72. J. Bracken to Roothaan, 2 November 1840, Roman letters.

A school that survives for 150 years has seen an enormous investment of human love and effort. If it succeeds, as Belvedere has succeeded, it is often sought out for the wrong reasons, as a sort of social ladder to enable boys to grow rich rapidly, safely and perhaps honestly. If that was the pattern of Belvedere, it would have failed in its deepest purpose, which is to make men for others, rather than individualists intent on their own life or their own soul; to make men who know they have received great blessings and want to make a return; who find God both in the sacramental life of the Church and in the needy of this world. Teachers are springtime workers, sweating to harrow the ground and sow the seed, but seldom seeing the harvest; most of the time made to feel they are unprofitable servants. But as this Jubilee approaches there must be some room for a contented and grateful look back. On all the evidence, the effort has been worth while.

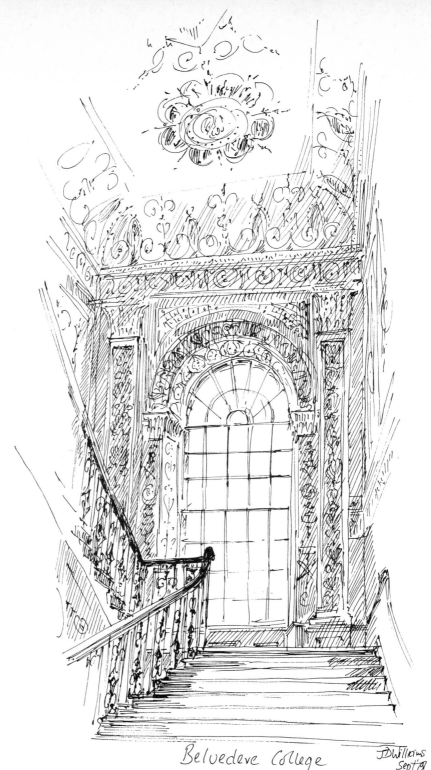

Belvedere College
The Staircase (1786)

JD Williams
Sept 81

160

SOURCES OF ILLUSTRATIONS

Front cover. The front door of Belvedere House. (*Derek Speirs*)
Back cover. The gate entrance to Belvedere College. (*Derek Speirs*)
Endpapers. James Mahony's 'View of Dublin taken from the spire of St George's Church', watercolour, 1854. Belvedere House is the second house from the left on the bottom of the right-hand page, directly opposite North Great George's Street. (*National Gallery of Ireland*)

All illustrations in this book, other than those listed hereunder, are taken from the Belvedere College archives, and except for those on pp. 47, 126, 133, and 140, have all appeared in past issues of *The Belvederian.* The sources of the remaining illustrations are as follows:

Derek Speirs. pp. 2, 4, 27, 37, 42–3, 60–61, 72–3, 82–3, 87, 93, 95, 100–101, 112, 114–15, 117, 122–3, 127, 134–5, 138, 142–3, 150–51, 156–7.

Jeremy Williams. pp. ii, 5, 11, 31, 119, 160

National Library of Ireland. pp. 9, 14, 121

Bord Failte. p.10

LIST OF SPONSORS

Main Sponsors

Bank of Ireland, Brennan Insurances Ltd, Patrick Concannon, Vincent, James and Eugene Davy, Conor Dean, Sun Aer Travel, Margaret Devereux and Family, John Donnelly, Educational Building Society, Irish Intercontinental Bank Ltd, Felix Jones, James Stewart, United Dominions Trust (Ireland) Ltd.

Supporting Sponsors

Percy Banahan, Denis J. Bergin, Kevin Blake, Noel Blake, Ivar McG. Boden, Charles J. Brennan, Louis J. Brennan, Patrick J. Brennan, John F. Bristow, John R. Callanan, James C. Carr, Church and General Insurance Co. Ltd, Bernard J. Clare, Richard Dennis, Sean Dillon, James Doody, Peter Dunn, Esso Teo., David Fitzgerald, David Foley, Desmond Forristal, James A. Geary, Michael Gill, William J. Gill, Edward G. Gleeson, John F. Gleeson, Peter Gleeson, Joseph Hackett, Don Hall, John D. Hamill, Christopher Heron, Patrick J. Higgins, Reginald Jackson, Damian Jennings, Fergus Jordan, Thomas Jordan, Bart Keaney, Peter Kearns, Owen Kelly, Robert Kidney, Brian Lenihan, Donal S. McAleese, R. Peter McCabe, Patrick C. McEvoy, Michael Madigan, Diarmuid Moore, Gervase Muller, Padraic Murray, Martin I. Nolan, Mahon O'Brien, Oliver O'Brien, Charles J. O'Connell, John M. O'Connor, James StL. O'Dea, Michael O'Dwyer, Diarmuid O'Hegarty, Desmond Rea O'Kelly, Dermot O'Mahony, Brian Rhatigan, Edward Rhatigan, Richard Richards, Thomas Ryan, James Sherlock, Andrew Smyth, Samuel Stephenson, George A. Stokes, Lexie Tynan, Vincent Walsh, Frank Young.

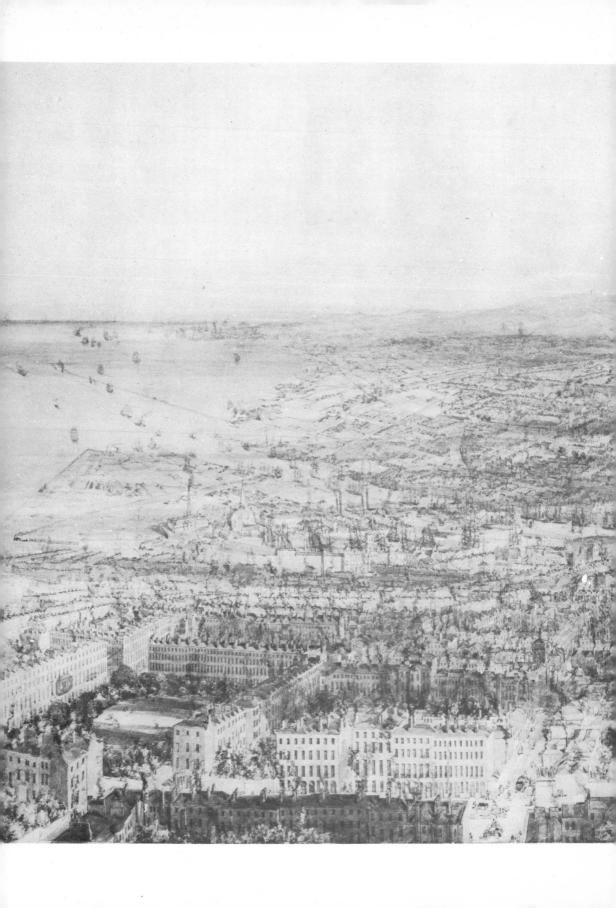